HOLY CARDS

Happy 40th, Mom!

Love ya, kid!

Donna

P.S. Thanks for all you have done for me!

HOLY CARDS

by Barbara Calamari & Sandra DiPasqua

Harry N. Abrams, Inc., Pubishers

Editor: Christopher Sweet
Designer: Sandra DiPasqua
Production Manager: Justine Keefe

Library of Congress Cataloging-in-Publication Data
Calamari, Barbara.
 Holy cards / by Barbara Calamari & Sandra DiPasqua.
 p. cm.
 Includes bibliographical references and index.
 ISBN 0-8109-4338-7 (hc)
 1. Holy cards. 2. Printed ephemera. 3. Christian art and
symbolism—Modern period, 1500– I. DiPasqua, Sandra. II. Title.
 NE958.C35 2004
 760'.04482—dc22
 2003015832

Printed and bound in China

10 9 8 7 6 5 4 3 2 1

Harry N. Abrams, Inc.
100 Fifth Avenue
New York, N.Y. 10011
www.abramsbooks.com

Abrams is a subsidiary of

ACKNOWLEDGEMENTS Many thanks to our agent Jim Fitzgerald and our editor Christopher Sweet of Abrams Books, who made this project such a pleasure to work on. We were in touch with several holy card collectors who were very supportive in their communications with us, among them, Sister Mary Jacque Benner and Pierluigi Stradella. James Occhino lent us some real treasures from his family collection and Mr. Fred Pfefferlein of PekaVerlag kindly allowed us to use several of his company's beautiful images. Patricia Bates and Louis Turchioe are owed a special debt for their unconditional support. We are also grateful to Deborah Rust for her generosity and technical expertise. Brian Tully was a great help with his knowledge of Photoshop. Kate Castellucci and her devotion to St. Anthony deserves a special thank you.

The best thing about working on this project was the opportunity we had in meeting Father Eugene Carrella, Pastor of St. Adalbert's Parish on Staten Island, New York. Father Carrella is not only one of the foremost collectors of holy cards in America, he is also someone who cared deeply enough about this project to assist us with research information as well as provide us with the majority of our images. Working with him has been an educational and thoroughly enjoyable experience.

Finally, we would like to dedicate this book to our parents, Virginia and Anthony DiPasqua and Leonora and Raymond Calamari.

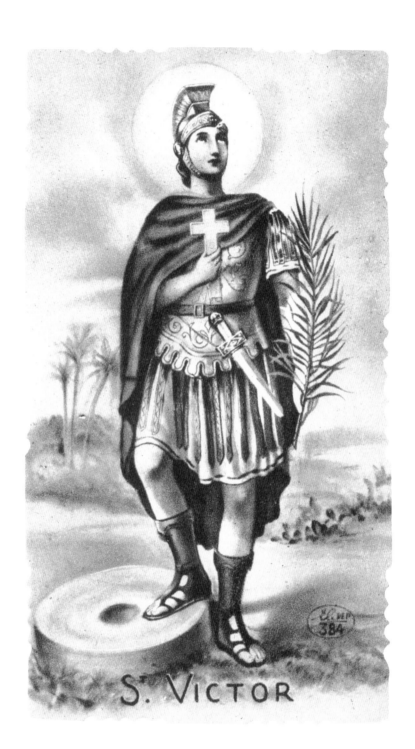

S. VICTOR

CONTENTS

O VERGINE, DECORO DEL CARMELO,
LE PORTE A FIGLI TUOI APRI DEL CIELO.

INTRODUCTION

The saints were human beings with human problems. They had bad marriages, debts, wayward children; they came from all walks of life. Yet through divine grace they were able to overcome their own personal obstacles and transcend the burdens of the material world. To Catholics they are an extended family that serve as a great inspiration in the ability of prayer and faith to change one's life. They have fascinating stories of suffering, failure, and victory, and many of us implore our favorite saints to pray with us and for us. They are not idols with magical powers, but they are mentors with whom we are able to identify. Since great art, architecture, and music are believed to be divinely inspired, visual art is an important element in Catholic religious expression. Frescoes in churches and stained glass windows traditionally served to instruct those who could not read. Images had to be designed to tell a story using objects, symbols, and colors that had their own significance. Many holy cards, besides being a visual physical portrait, also display the elements of a saint's story or patronage.

This book does not contain every saint or every style of holy card. Some of the most popular saints are not here at all and the small amount of information given with each picture is there to help understand the image, not to tell the entire story of the saint's life. There are many obscure saints here who are popular only in a few small towns or in religious communities. We have tried to put in different examples of the type of art available and have divided our chapter sections in a very basic way. Many saints could qualify for placement in several of these divisions. Cards that were created over 100 years ago have a different visual vocabulary than the more recent portrait-style cards. We found that the older cards were created using standard artists' guides compiled in the Middle Ages for saints and their attributes. Having a knowledge of the meanings of the elements in these cards enables the image to be enjoyed on a deeper level. We have compiled lists of these elements, and in the back of this book is a bibliography where more complete lists can be found. We have interspersed cards that were popular a century ago with cards that are mass produced today. Though their artistic styles may vary widely, they have one thing in common: they were never considered precious art objects; they were meant to be carried and casually displayed, much like family photographs.

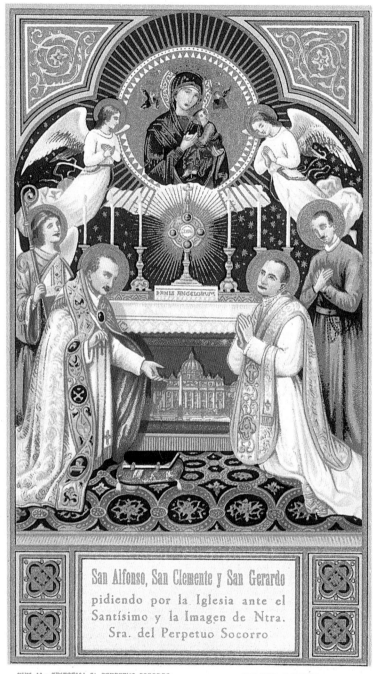

San Alfonso, San Clemente y San Gerardo
pidiendo por la Iglesia ante el
Santísimo y la Imagen de Ntra.
Sra. del Perpetuo Socorro

NÚM. 14 - EDITORIAL EL PERPETUO SOCORRO
MADRID

LIT. S. DURA - A. GUIMERÁ, 39 - VALENCIA
DEPOSITO LEGAL V - 1031 - 1961

A Brief
History

It is not easy to tell an entire story in one still image, yet this is what holy cards attempt to do. They present a visual biography of a saint's life. Inspired by paintings, these little portable images began as woodcut prints in the early fifteenth century. This process offered an inexpensive way for those unable to afford custom artworks to own an image of their patron saint. At that time in Europe, every village town and person was under the patronage of a saint. Having an image of one's saint was considered a form of protection. Handmade devotional cards utilized parchment, lace, and black ink-etched portraits. They were popular gifts, and our present-day lace Valentine's Day cards are direct descendants of these early saints' cards. In 1796 Aloys Senefelder invented lithography, a printing process which made the mass production of images possible. Soon after, the Benziger brothers developed a major business of printing religious images in Switzerland. With the advent of chromolithography these saints' pictures could be printed in color. By the mid-nineteenth century Benziger was the foremost producer of "Santini" or little holy pictures. Local companies followed suit and each country developed its own distinct way of presenting a devotional image. In France, the area around the Church of San Sulpice became a major marketplace for religious goods. The San Sulpice holy cards are more sentimental and pastel toned. They have a painterly style, much like the French academic salon art of the late 1800s. Cards made in Belgium were created with more graphic color and sophisticated artistic styles. The "wallpaper" or background patterns have an Islamic influence. The subject matter is presented in a very enigmatic way, with the saints holding objects that are relevant to their

B. Henricus de Calstris,
Lovaniensis. O.P.

3S. Steendr: H. van de Vyvere-Petyt, Brugge.

stories. Swiss and German cards tend towards a fairy tale illustrative quality while Italian, Spanish, and Mexican cards are based on the presentation of the saints in fine art. When looking at these cards from a century ago, they are so exquisitely printed and manufactured that it is hard to believe that they were bought for pennies as little, disposable keepsakes.

Presently, while holy cards are produced in the millions, there is less diversity in style and quality. Many companies still use the paintings of one hundred years ago with their mysterious objects and symbols embedded in them, but modern people are less able to read them. Cards of more recent saints like St. Thérèse of Lisieux, Mother Cabrini, or Padre Pio are basic photo-like portraits resembling head shots or publicity stills. It is no longer considered necessary to try and include the mysterious elements that tell a story. In perusing the many pages of artists' lists it becomes apparent that the average person of a century ago was able to read much more into a picture than people of today.

Holy cards are extremely important to Catholics. Many still carry them for protection or out of loyalty to a patron saint. They are given as remembrances for communions, confirmations, and most commonly, at wakes and funerals. Prayers are put on the back with the name of the deceased, their birth and death dates. Even the least devout save these cards as a tribute. They are used as bookmarks, kept in drawers, carried in wallets, or openly displayed. They contain images that are comforting, disturbing, and extremely powerful in that they trigger strong emotions. Because they are not considered precious works of art but standard everyday objects, holy cards are a wonderful example of folk art pieces that help expand our spiritual lives.

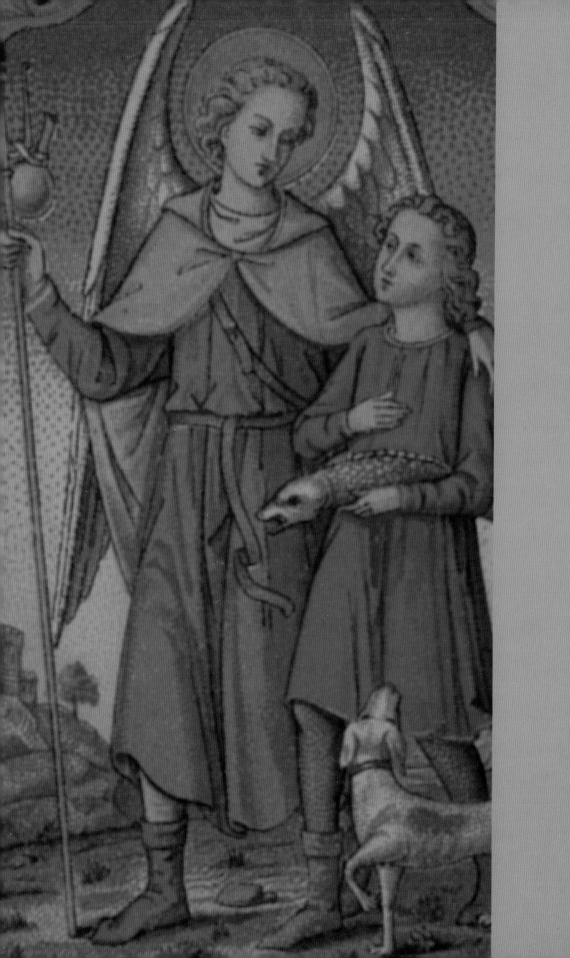

PROPHETS
&ANGELS

When God speaks to man, he does so either by sending an angelic messenger or through divine inspiration. Angels are ethereal bodies known as the messengers of God. They appear at times of great duress, such as the apparition of Michael atop what is now Castel Sant'Angelo in Rome, announcing the end of a devastating plague in the fifth century. They deliver unexpected news. The angel Gabriel is always shown holding the proclamation announcing the conception of Christ to the Virgin Mary. Many travelers still call on the Archangel Raphael for help when they are lost.

Prophets are not divine in any way; they are the human recipients of revelation from God. Prophets are frequently reviled and mocked in their own lifetime. They burn with the truth and cannot be put off from their mission. Most prophets appeared before the birth of Christ with news of His coming. Elias foretold the coming of Mary as the Mother of God eight centuries before her birth and began a great devotion to her. John the Baptist announced the coming of Christ.

It has become customary to put the three Archangels—Gabriel, Michael, and Raphael—together. Though their individual patronages differ, they now share the same feast day. Catholics believe that they are present at all times and call on them in difficult situations for their help in relaying a clear message from God.

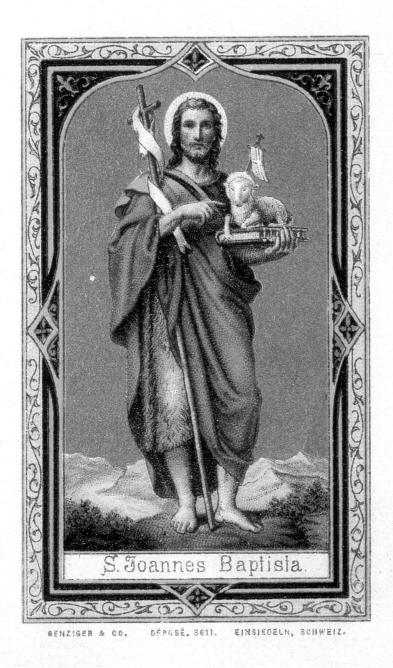

S. Joannes Baptista.

BENZIGER & CO. DÉPOSÉ. 3611. EINSIEDELN, SCHWEIZ.

SAINT JOHN THE BAPTIST Died 30 A.D. Feast Day: June 24. Patron of: Lambs. Baptism. Monks. A cousin of Christ, John began preaching in the wilderness that people should repent because the kingdom of heaven was at hand. He would baptize his followers, Christ among them, in the river Jordan. He hailed Christ as the lamb of God in reference to Isaiah's image of the lamb led to slaughter to bear the sins of mankind, and also because of the custom of sacrificing a lamb at Passover. He holds the banner of Christ with a lamb on the book of innate knowledge.

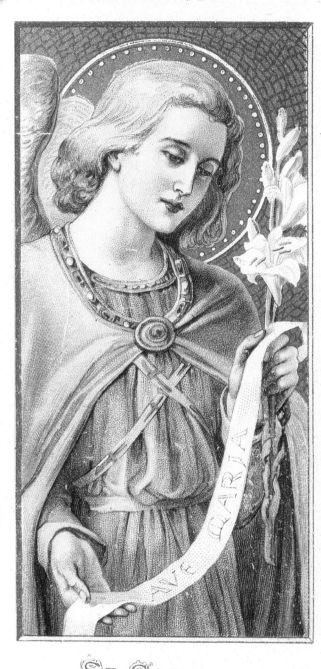

ST. GABRIEL.

SAINT GABRIEL THE ARCHANGEL Feast Day: September 29. Patron of: The Communications Industry. Postal Workers. Teachers. Parents. Gabriel is most famous for the Annunciation, when he appeared to the 14-year-old Mary and told her she was to give birth to the Divine Savior. He holds lilies for Mary's virginity and a proclamation reading, "Ave Maria..." "Hail Mary..."

18

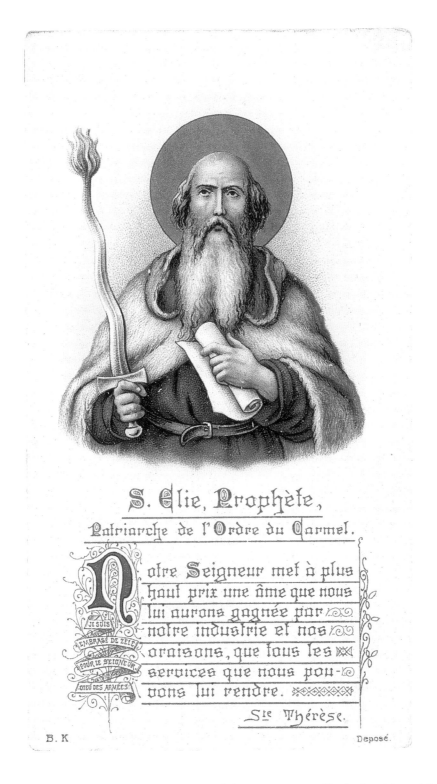

S. Elie, Prophète,
Patriarche de l'Ordre du Carmel.

Notre Seigneur met à plus haut prix une âme que nous lui aurons gagnée par notre industrie et nos oraisons, que tous les services que nous pouvons lui rendre.

JE SUIS EMBRASÉ DE ZÈLE POUR LE SEIGNEUR DIEU DES ARMÉES.

Ste Thérèse.

B. K

Deposé.

SAINT ELIAS Eight hundred years before the birth of the Virgin Mary, Elias had a vision of the coming of the Mother of God. While meditating on Mount Carmel, he and his followers held a mystical dedication to her. The descendants of his followers were among the first to be baptized and they dedicated one of the first monasteries in Mary's honor on Mount Carmel. Elias is the inspiration for the Carmelite order. He is depicted in Carmelite habit, holding the flaming sword of ardent authority and a scroll of the Carmelite rule.

Sᵘˢ MICHAËL ARCHANGELUS

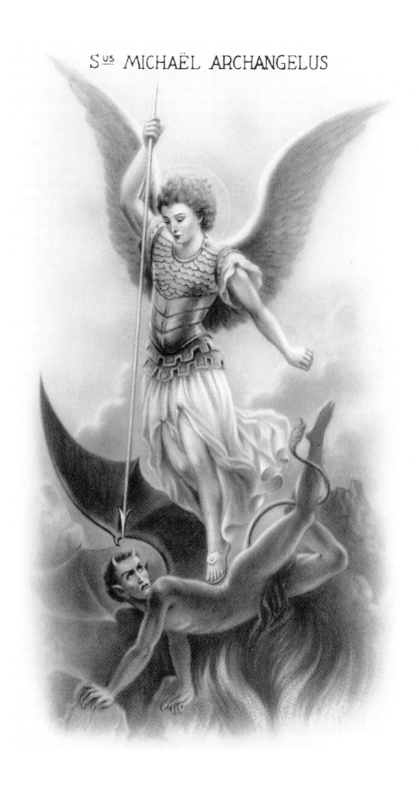

SAINT MICHAEL THE ARCHANGEL Feast Day: September 29. Patron of: Grocers. Policemen. Soldiers. Michael was the angel who defeated Lucifer in his uprising against God and cast him into hell. He is also the one who weighs the sins and the good deeds of the newly departed souls. He is frequently depicted with a set of scales. Here he is shown defeating evil in the guise of Lucifer.

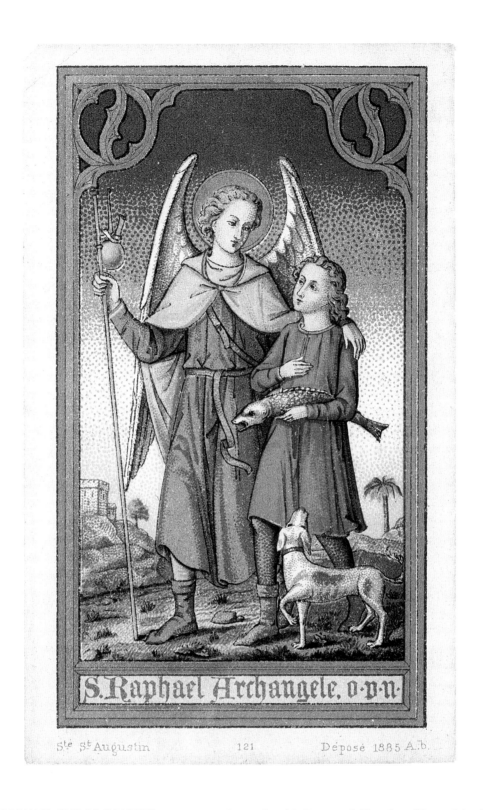

S. Raphael Archangele, o·p·n·

Ste Stᵉ Augustin 121 Déposé 1885 A.b.

SAINT RAPHAEL THE ARCHANGEL Feast Day: September 29. Patron of: Travelers. Happy Meetings. The Blind. Science. Healing. This card is a depiction of the story of Tobias. His father had been struck blind and could not accompany him on a trip across the desert. Tobias called on the archangel who did so in disguise. Along the way he introduced Tobias to his future wife and advised him to burn the innards of a fish they had caught for lasting happiness. When this was done the father was cured of his blindness.

21

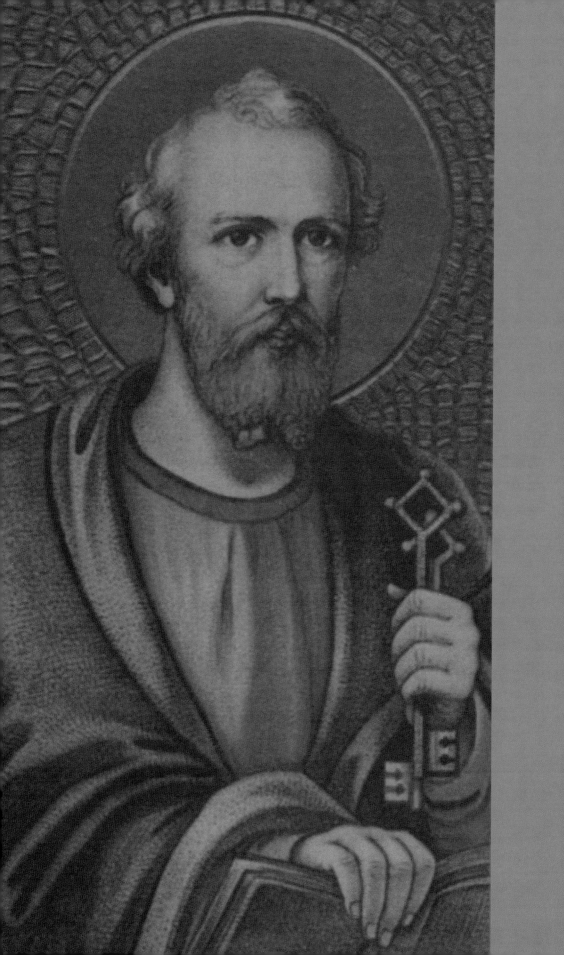

DISCIPLES
&EVANGELISTS

There are four authors of the gospels, Matthew, Mark, Luke, and John. Since the sixth century their presence in art has been very important because their personalities and their writings are pictorially symbolized as four different winged creatures. The use of symbols to illustrate individual character traits influenced the depiction of many other saints. Most of the early apostles and disciples enjoy great importance in the cities of which they are patrons of. Their symbols are found everywhere in local architecture, statuary, and paintings.

Ironically, the apostle with the most universal appeal is Jude, the Saint of Impossible Causes. Because his name was so similar to Judas, the traitor who betrayed Christ, no one invoked him for anything. As a remedy to this, Saint Jude promised to help those with the most impossible problems. To this day, there is a statue to him in almost every Catholic Church and his intercession is widely sought.

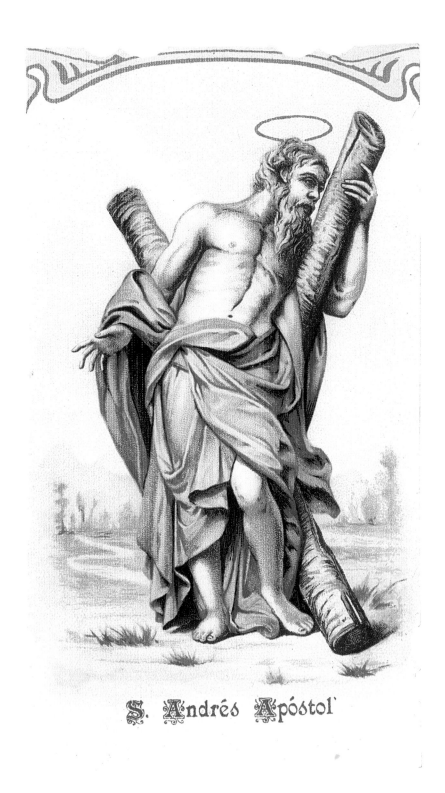

S. Andrés Apóstol

SAINT ANDREW First Century. Feast Day: November 30. Patron of: Scotland. Russia. Amalfi. Fishsellers. Spinsters. *The first of the twelve original apostles, Andrew was a follower of John the Baptist before he became a disciple of Christ. He was martyred in Greece for converting the governor's wife to Christianity. He was bound to an X shaped cross and it was said he continued preaching for two days until his death.*

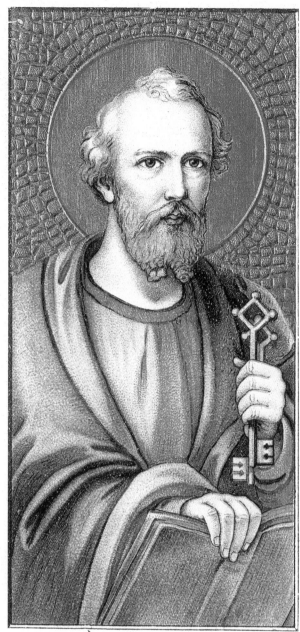

ST. PETRUS.

SAINT PETER First century. Feast Day: June 29. Patron of: The Universal Church. Stone masons. Bakers. Peter was the leader of the original twelve apostles. His bad temper and errors in judgement make him the most human of apostles. It was to him that Jesus left the leadership of his church, calling Peter the rock. He was martyred in Rome by being crucified upside down, and the site of his tomb is now Saint Peter's Basilica. He holds two keys, one of heaven, one of hell. He has an open book for the wide ranging spread of the faith.

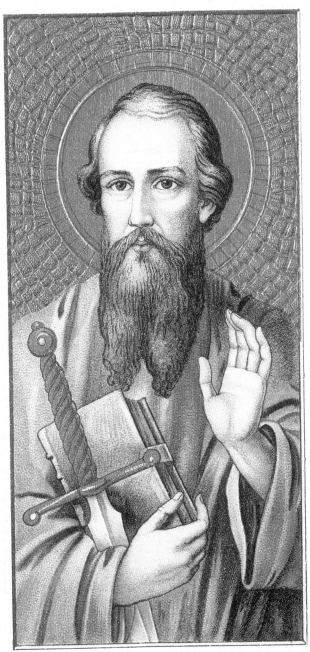

ST. PAULUS.

SAINT PAUL First century. Feast Day: June 29. Patron of: Evangelists. Snake bite. Malta. Journalists. Formerly an enemy of all Christians, Paul was knocked off his horse by a blinding light on the road to Damascus. For three days he was unable to see or eat while Christian teachings were infused in him. He became a zealous preacher of Christianity, traveling all over the ancient world. He was martyred in Rome. He holds his hand in blessing, he has the closed book of innate knowledge, and his attribute is a sword because he was beheaded and he was a great leader.

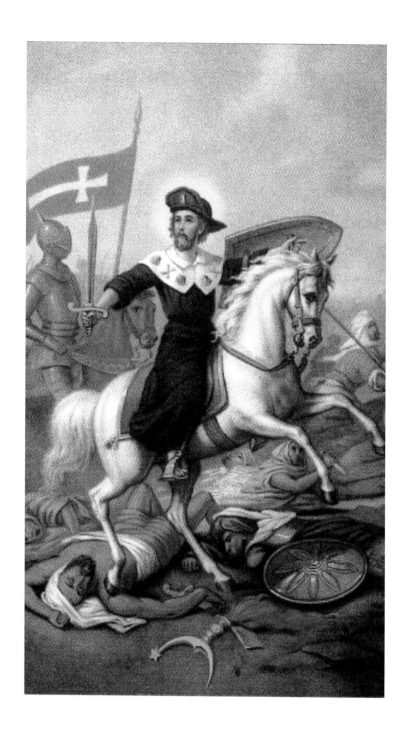

SAINT JAMES First century. Feast Day: July 25. Patron of: Spain. Pilgrims. Equestrians. Druggists.
James the Greater was one of the original apostles. According to tradition he preached the gospel as far
as Spain. He returned to Judea and was put to death. His body was set out in a boat which washed up
on the coast of northern Spain. The great Cathedral of Santiago de Compostela was built to house his
relics. This became a great pilgrimage center. Saint James was the patron of the Christians fighting off
the Moorish invaders. He is shown in pilgrimage garb on a white charger leading the battle.

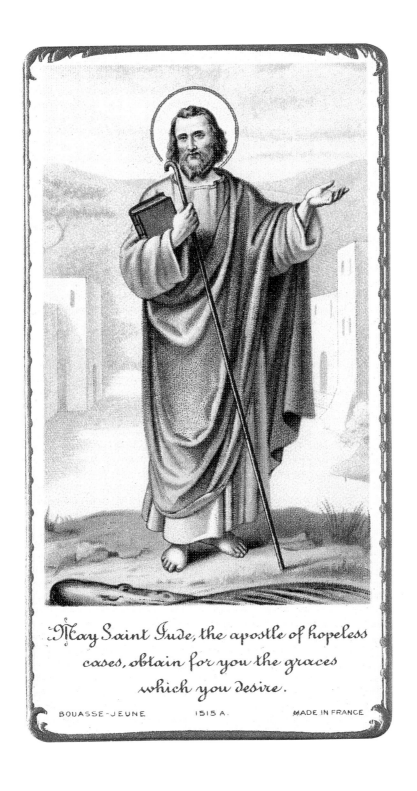

May Saint Jude, the apostle of hopeless cases, obtain for you the graces which you desire.

BOUASSE-JEUNE 1515 A. MADE IN FRANCE

SAINT JUDE First century. Feast Day: October 28. Patron of: Impossible causes. One of the original twelve apostles, Jude was a cousin of Jesus. He is frequently depicted with a flame at his head as a sign he had been inspired by the Holy Spirit. The stick he carries is the implement of his martyrdom and his hand is in a gesture of invitation.

29

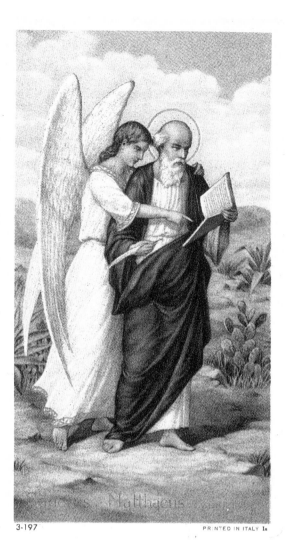

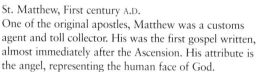

3-197 PRINTED IN ITALY In

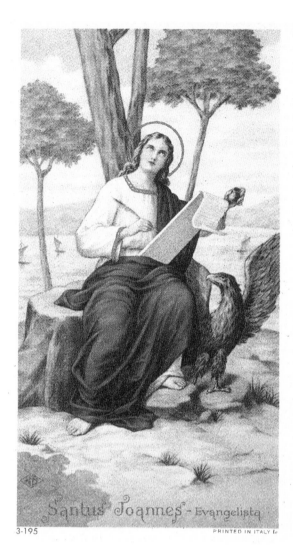

3-195 PRINTED IN ITALY Ir

St. Matthew, First century A.D.
One of the original apostles, Matthew was a customs agent and toll collector. His was the first gospel written, almost immediately after the Ascension. His attribute is the angel, representing the human face of God.

St. John, First century
The youngest and most beloved of the original apostles, he was entrusted with the care of the Virgin Mary after Christ's crucifixion and Ascension. He wrote his gospel to refute blasphemies. He died at Ephesus after a long life. His tomb is famous for miracles. His attribute is the eagle which references the spiritual nature of his gospel. When it appears in other saint's cards, it is always in reference to St. John.

THE FOUR EVANGELISTS The prophet Ezekial (1:5–14) had a vision where he described four strange winged creatures, each with a four-sided head and on each of the four sides a different face. On the front was the face of a man, on the right side that of a lion, on the left side that of an ox, and on the back that of an eagle. The Book of Revelation (4: 6–8) describes similar creatures surrounding the throne of God (Apocalypse, 3). By the Middle Ages, these animals became attributes of the four evangelists who wrote the gospels.

According to the early Church fathers, these attributes represent the humanity, the passion, the resurrection, and the divinity of Christ that are hidden in the individual gospels. Matthew is represented

30

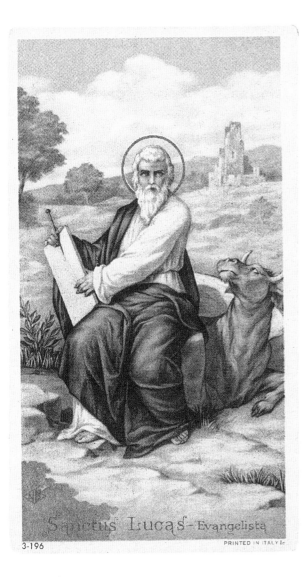

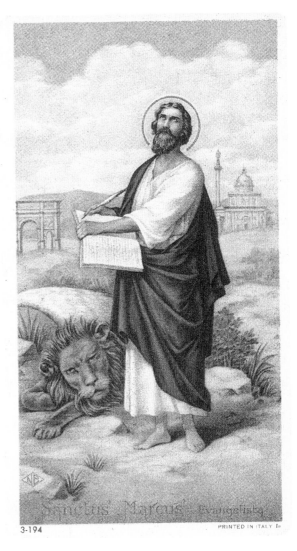

St. Luke, First century
A disciple of St. Paul, Luke was a physician and artist.
He is credited with the only painting made of the Virgin
Mary. He was crucified on an olive tree in Thebes. Some
of his relics are kept at the great monastery on Mount
Athos in Greece. His attribute is the ox, representing
Christ's sacrifice.

St. Mark, First century
Assistant to St. Peter, his gospel was written in A.D. 49. He
was martyred in Alexandria by being dragged through the
streets. In 815 his body was stolen by the Venetians, who
interred it in the basilica built in his name. His attribute is
the lion, representing the resurrection.

with a man (winged angel) because he mostly dwells on the humanity of Christ. His gospel opens with
the tree of the ancestors of Christ. Mark opens with the voice crying in the wilderness, an allusion to the
lion. Mark also dwells the most on the resurrection, and it was believed that lion cubs were born dead
and took three days to be brought to life by being licked by their sire. A lion also symbolizes a life's
work. Luke's gospel concentrates on the sacrificial aspect of Christ's actions, hence his attribute would be
an animal, the ox, which was frequently used in sacrifices. The eagle, of all the birds, is the one who flies
nearest to heaven and John was the apostle who was closest to Christ and who concentrated on His
divinity in his gospel. Besides their individual animal attributes, the evangelists are always shown writing
with a book or scroll in their hands.

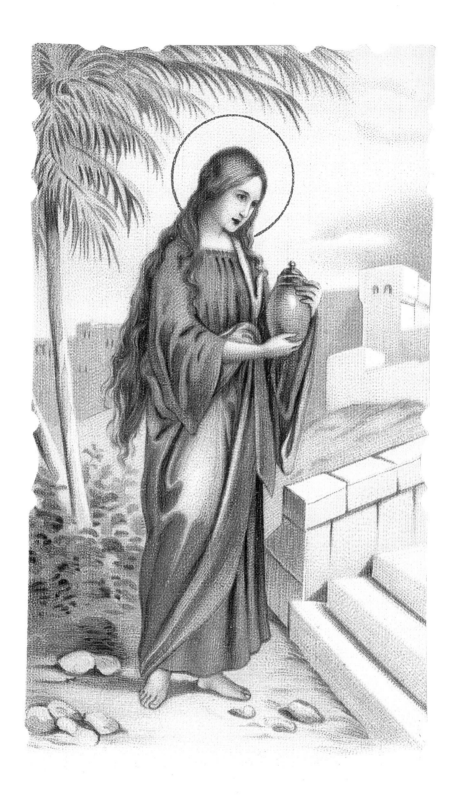

SAINT MARY MAGDALEN First century. Feast Day: July 22. Patron of: Penitents. Reformed
Prostitutes. Glovemakers. Hairdressers. An infamous prostitute converted by Christ, Mary Magdalen
became His follower and friend. She is always shown with long hair and a jar of oils. In gratitude of
His social acceptance of her, she washed His feet, dried them with her hair, and anointed them with oil.
She was the first person to whom the risen Christ appeared. After His Ascension, she was set adrift in
a boat and landed in Marseilles, where she lived an ascetic and penitent life.

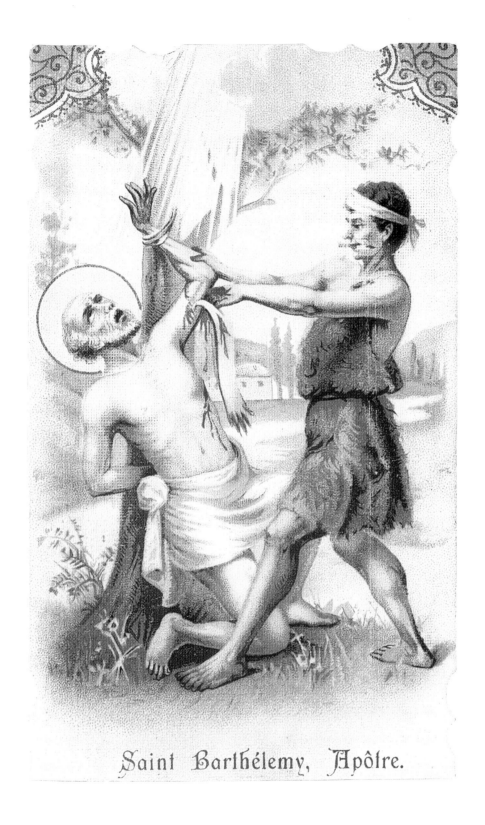

Saint Barthélemy, Apôtre.

SAINT BARTHOLOMEW First century. Feast Day: August 24. Patron of: Tanners. Cheese merchants. Armenia. Bartholomew was one of the original twelve apostles who preached in Asia Minor, Ethiopia, and India. He was martyred in Armenia by being flayed alive. The knife used to skin him resembles a cheese cutter. For this reason he has that patronage.

St. Peter, O. P.

Blessed are ye when they shall revile you and persecute you, and speak all that is evil against you, untruly, for my sake.

St. Matthew. V. 11.

St. Fidelis

St. Anthony of Hungary

St. John of Cologne

St. Eugene

St. Ursula

Bl. Peter Sanz

St. Agnes

St. Lucy

St. Barbara

St. Cecilia

St. Susanna

St. Emydius

MARTYRS

St. Apollonia

St. Laurence

St. Sebastian

St. Liverius

St. Iraeneus

St. Renatus Vitalis

St. George

St. Philoterus

St. Margaret of Antioch

St. Peter of Verona

The Greek word *martus* means "witness who testifies to a fact." Within the lifetime of the first Apostles, the term *martyr* began to be used for witnesses who, though they had never seen or heard Christ, were so convinced of the truths He spoke that they gladly suffered death than deny them. The first saints were those who died for their faith. Martyrs are the embodiment of those who know that physical suffering, like physical life is a temporary state.

The stories of the martyrs are the most popular, offering heroic tales of victory in defeat, of life over death. They are also lurid, gruesome, and shocking. The holy cards of the martyrs usually include the particular implements of torture and death suffered. The saints also hold palms, an ancient sign of victory.

While Apostles and members of religious orders are almost expected to have the fortitude to suffer such harrowing fates, it is the cults of the Virgin martyrs that are the most admired. These examples of innocent young girls, representing the most vulnerable and powerless members of society, defiant in the face of great power, still inspire great followings.

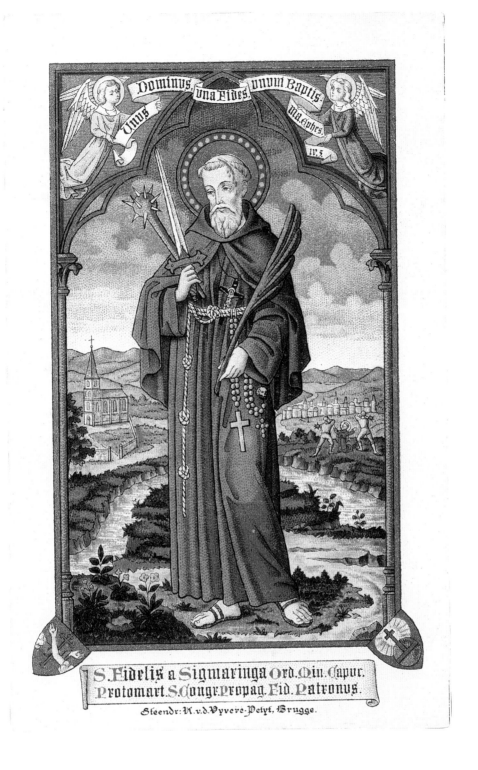

SAINT FIDELIS OF SIGMARINGEN 1577–1622. Feast Day: April 24. A lawyer disgusted with the corruption in the justice system, Fidelis gave away his worldly wealth and became a Franciscan monk. He led a group of Capuchin friars on a mission to the Protestant area of Switzerland and was martyred for his preaching. His card has the shield of the propagation of the Faith, he has a cut in his head, and he holds the sword and whirl bat with which he was martyred in one hand, martyrs' palms in the other.

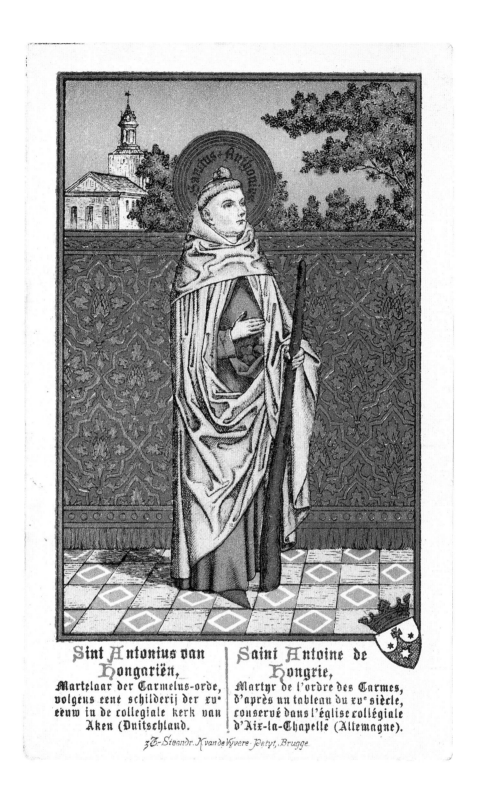

Sint Antonius van Hongariën,
Martelaar der Carmelus-orde, volgens eene schilderij der xvᵉ eeuw in de collegiale kerk van Aken (Duitschland.

Saint Antoine de Hongrie,
Martyr de l'ordre des Carmes, d'après un tableau du xvᵉ siècle, conservé dans l'église collégiale d'Aix-la-Chapelle (Allemagne).

z Æ-Steendr. K van de Vyvere-Petyt, Brugge.

SAINT ANTHONY OF HUNGARY was a Carmelite who was stoned to death. The rocks in the image are symbols of his martyrdom. The shield of the Carmelite order is on the lower corner.

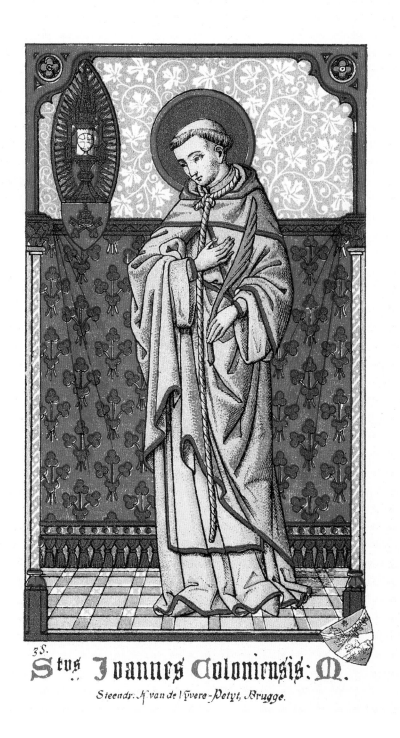

3S.

Stvs Joannes Coloniensis: M.

Steendr. A van de l'yvere-Petyt, Brugge.

SAINT JOHN OF COLOGNE Died 1572. Feast Day: July 9. John was a Dominican priest who could not wear his habit because of the persecution against the church. He was caught smuggling communion to Catholic prisoners in Gorkum, Netherlands. He wears the rope he was hung with, while holding martyrs' palms. The monstrance with the host glows near him. The shield of his order is at the bottom of the card.

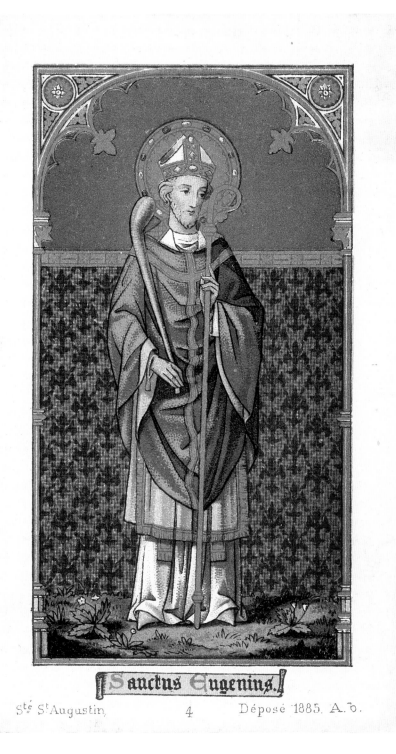

Sté St Augustin 4 Déposé 1885. A. b.

SAINT EUGENE OF PARIS Died 280. Feast Day: November 15. A companion to Saint Denis, Eugene was a bishop. He holds the club with which he was beaten to death.

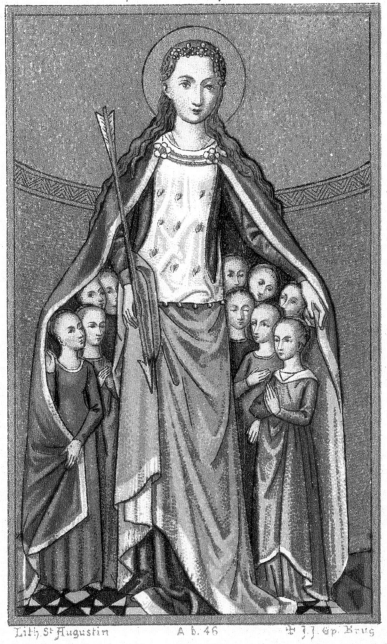

Sainte Ursule:

Lith. St Augustin A b. 46 ✝ J.J. Gp. Krug

SAINT URSULA AND HER COMPANIONS Died Fourth century. Feast Day: October 21. Patron of: Teachers of Girls. Germany. Daughter of a British king, Ursula traveled the continent with eleven young women on a pilgrimage to Rome. In Cologne, Germany, she and her companions were overtaken by an invading horde of Huns. Ursula and the girls died rather than submit to them. Ursula is sheltering her companions with her cloak. The arrow that killed her is in the foreground.

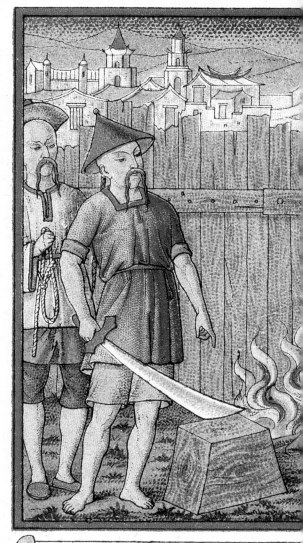

+ B.Petrus Sanz socio;
Joannem Alcober et Fran

os B.B.Franciscum Serrano, Joachim Royo,
um Diaz ad martyrium adhortatur.
oendr: K. van de Vyvere-Petyt, Brugge.

BLESSED PETER SANZ AND HIS COMPANIONS 1680–1747. Feast Day: May 26. Peter Sanz and his four companions were a group of Dominican missionaries credited with converting thousands of Chinese to Christianity. They were incarcerated by the governor of Peking. When they began converting their jailors and other prisoners, they were tortured by fire and executed on the chopping block.

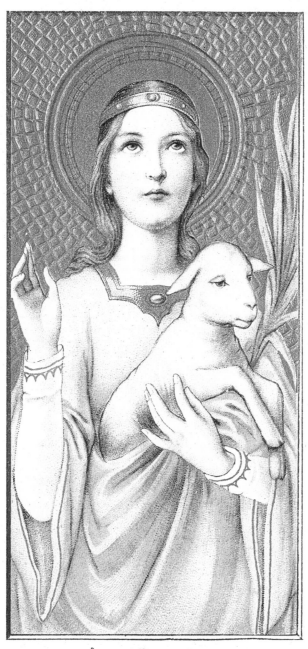

ST·AGNES

SAINT AGNES Died Third century. Feast Day: January 21. Patron of: Girls. Gardeners. Engaged couples. A beautiful 13-year-old girl, Agnes was denounced as a Christian when she refused all marriage proposals. Wanting to dedicate herself to Christ, she preferred death to losing her virginity. She offered herself as a martyr and was executed by being stabbed in the throat. Since she was a gentle creature, sacrificed, she has the lamb as her attribute.

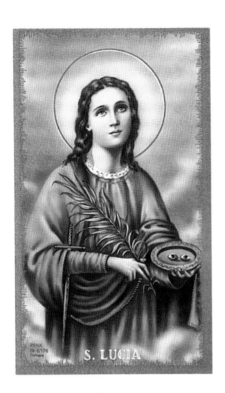

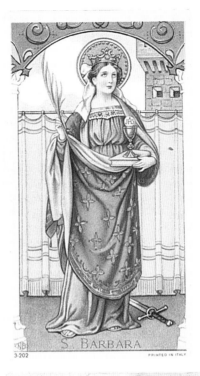

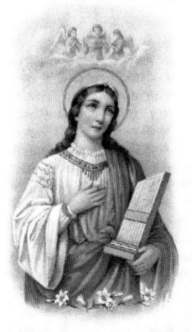

St. Cecelia, virgin Martyr, † 232.

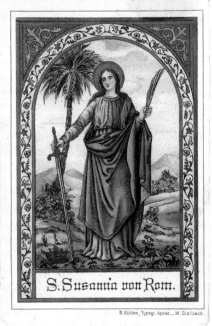

VIRGINS Saint Lucy, Saint Barbara, Saint Susanna, and Saint Cecilia are well known early Virgin Martyrs who were killed for refusing to give up their personal vows of celibacy.

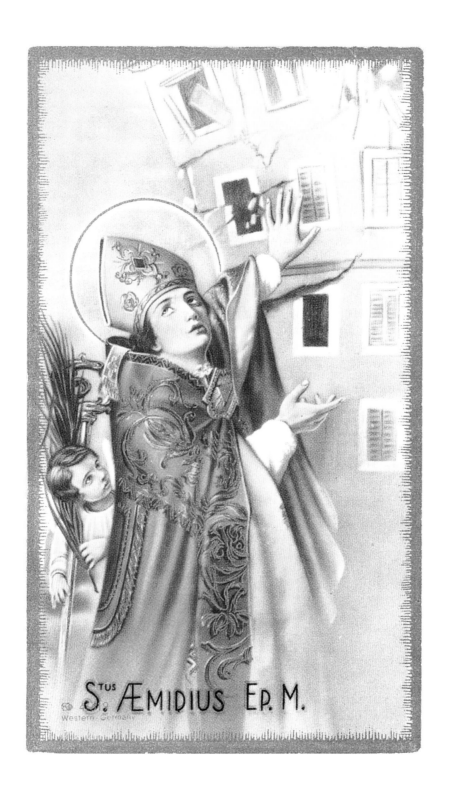

S^{tus}. ÆMIDIUS E<small>p</small>. M.

Western Germany

SAINT EMYIDIUS Died 303. Feast Day: August 9. Patron of: Earthquakes. Naples. Ascoli Piceno, Italy. A knight from Triers, Germany, Emyidius was a Christian convert. He is alleged to have smashed up pagan idols with great vigor and even to have caused a pagan temple to collapse. He was driven out of Germany, went to Rome and was made a Bishop. He was martyred in Ascoli Piceno, Italy. He is holding up a building falling in an earthquake, while a young boy holds his Bishop's crozier with his martyr's palms.

46

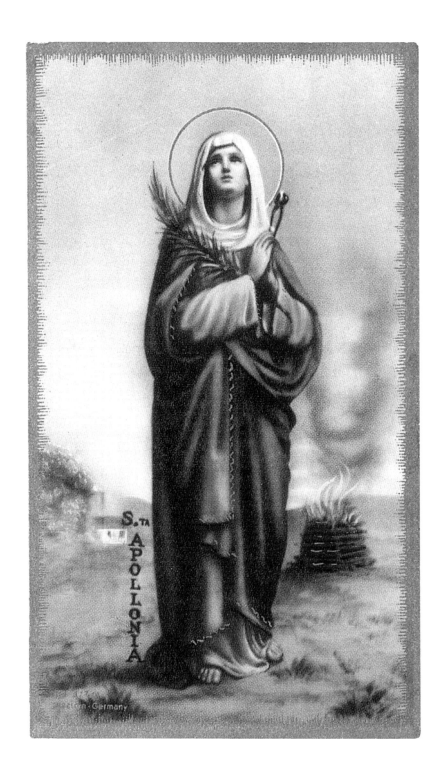

S.ta APOLLONIA

Stern-Germany

SAINT APOLLONIA Died 249. Feast Day: February 9. Patron of: Dentists. Apollonia was an older woman from Alexandria and a deaconess in the Christian church. During a purge of the Christians she had her teeth pulled out by pincers and was then burnt on a pyre. She holds her palms and the pincers. The fire burns in the background.

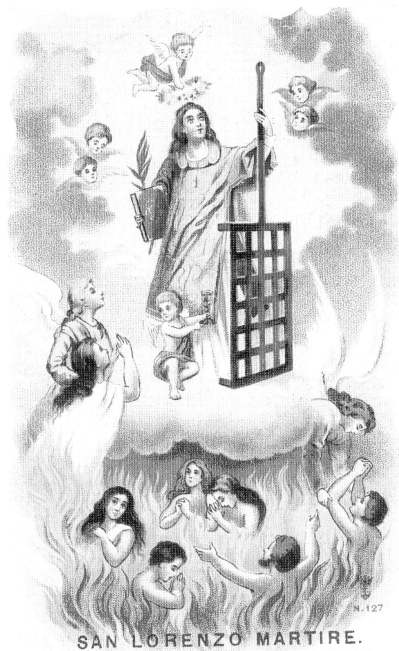

SAN LORENZO MARTIRE.

O Signore, per la potente intercessione del Santo Martire Lorenzo degnatevi ammettere le anime dei nostri cari Defunti al gaudio della sempiterna beata luce.

SAINT LAURENCE Died 258. Feast Day: August 10. Patron of: Cooks. Brewers. Confectioners. One of the seven deacons of Rome who was ordered by the Emperor to turn over the Church's treasures. He presented thousands of lepers, orphans, the blind, and the lame and said "here are the Church's treasures." For this he was tortured and grilled alive. He is said to lead one soul out of purgatory on every Friday. This card shows him holding his grill, wearing a deacon's gown, and choosing a soul in purgatory to lead to paradise.

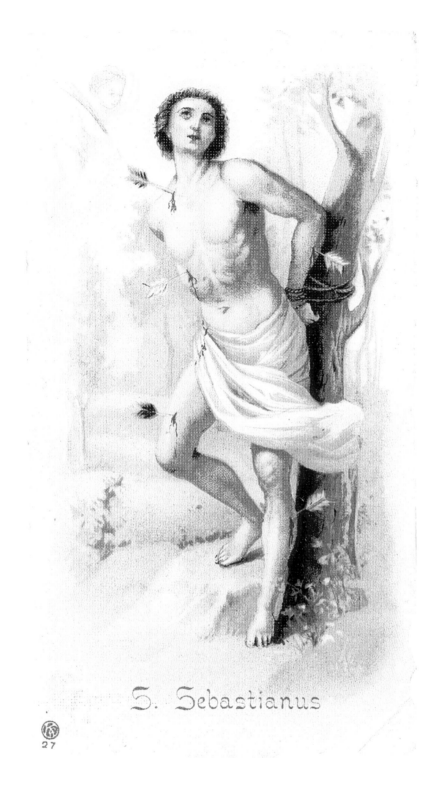

S. Sebastianus

27

SAINT SEBASTIAN Died 288. Feast Day: January 20. Patron of: Soldiers. Plague sufferers. Archers.
A Captain in the Praetorian Guards who kept his Christian religion a secret, Sebastian was found out
and ordered executed. He was tied to a tree and shot with arrows. A Christian woman found he was
not dead and hid him. He refused to flee the city. When he recovered, his superiors were astounded to
see him alive. He was then beaten to death and his body thrown in the sewer.

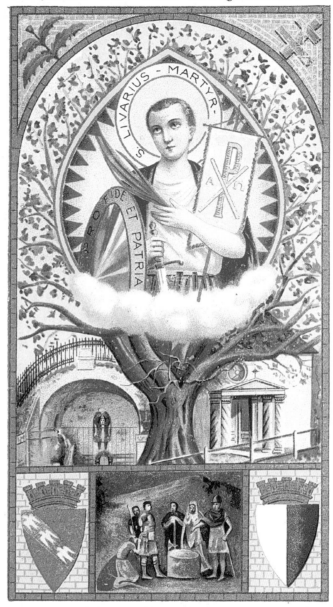

SOUVENIR DU PAYS-MESSIN
= Gruss aus dem Metzerlande =

S.ᵀ LIVIER, DEFENSEUR DE METZ

PÈLERINAGE
Fontaine. — Tilleul. — Chapelle.

SAINT LIVERIUS OF METZ Died 451. Feast Day: November 25. Liverius was a knight who defended his town against the Hun invasion. After killing the leader of the Huns, he was captured and decapitated. At the spot where his head dropped off, a spring of water miraculously erupted. The Huns ran out of the town in terror. A chapel was built on this spot and is a place of pilgrimage. Liverius has martyr's palms, a shield of protection, and the banner of Christ. Below him are illustrations of the chapel, the town of Metz, and a scene of his decapitation.

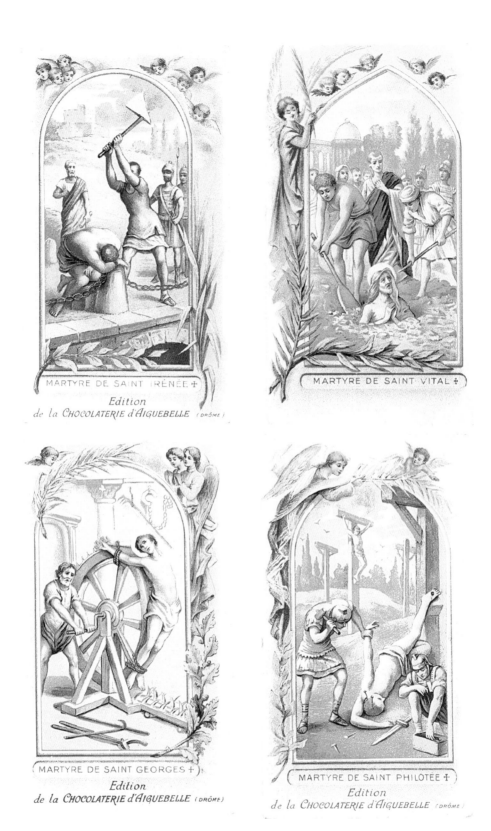

MARTYRE DE SAINT IRÉNÉE ✝

Edition
de la CHOCOLATERIE d'AIGUEBELLE (DRÔME)

MARTYRE DE SAINT VITAL ✝

MARTYRE DE SAINT GEORGES ✝

Edition
de la CHOCOLATERIE d'AIGUEBELLE (DRÔME)

MARTYRE DE SAINT PHILOTÉE ✝

Edition
de la CHOCOLATERIE d'AIGUEBELLE (DRÔME)

A SERIES OF MARTYR CARDS These are part of a series of Holy Cards distributed by a chocolate company owned by the Cistercian Trappist Monks in Aiguebelle, France, in the early 1900s.

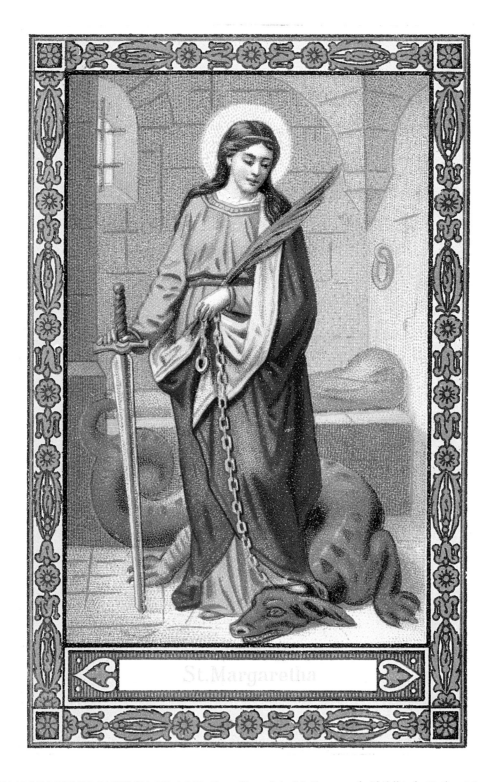

St.Margaretha

SAINT MARGARET OF ANTIOCH Died 303. Feast Day: July 20. Patron of: Childbirth. Exiles. Margaret was the Christian daughter of a pagan priest. When her father discovered her conversion he cast her out. She lived as a simple shepherdess. When she rejected the advances of a prelate, she was denounced for her Christianity and incarcerated. In her cell the devil appeared to her as a dragon and swallowed her. A cross she carried grew so large it split the dragon in two. She was then beheaded. She holds the sword that killed her and the dragon in chains at her feet.

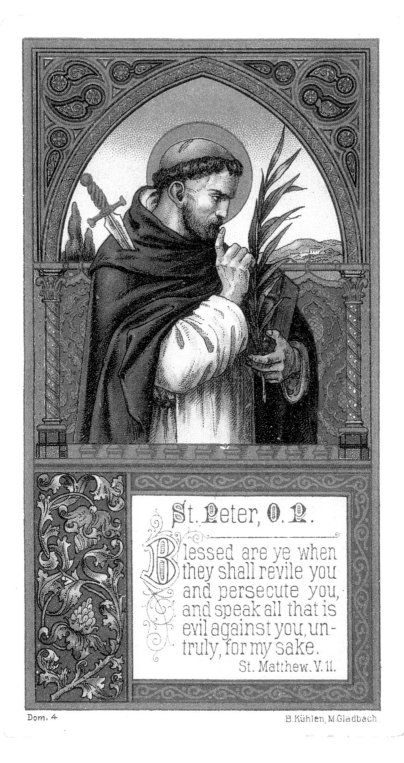

St. Peter, O. P.

Blessed are ye when they shall revile you and persecute you, and speak all that is evil against you, untruly, for my sake.

St. Matthew. V. 11.

Dom. 4

B.Kühlen, M.Gladbach

SAINT PETER OF VERONA 1205–1252. Feast Day: April 29. Patron of: Inquisitors. The son of Cathar heretics, he converted after hearing Saint Dominic preach. He joined the Dominicans and, as the Inquisitor for Northern Italy, did much to silence heresy. He was murdered for this and while he was dying wrote with his own blood on the ground, "Credo in unum Deo." "I believe in one God..." The dagger he was killed with is in his back. He is silencing heresy while clutching his martyr's palms and the closed book of secret knowledge.

HERMITS

It was the custom of many Old Testament prophets to meditate alone in the desert. Both John the Baptist and Jesus banished themselves, for a time, from society. Alone in the wilderness they fought their greatest battles with self-doubt in an attempt to purge their souls of all evil. The earliest hermits in the Christian era were those who were attempting to follow Christ by giving up all worldly comforts. They lived a life of austerity and self discipline, praying and contemplating death and human mortality. This is why a human skull is frequently seen in depictions of hermits and penitents. According to legend, Saint Paul the hermit was fed by a raven who dropped a loaf of bread for him every day. A raven, a loaf of bread, and a water jug are also common signifiers of those who lived that life.

The custom of withdrawing from society was not only practiced in the desert. Many retired into the forests of Europe throughout the Middle Ages. Those who did not want to join monastic communities remained in towns and villages and were formerly enclosed in cells built up against the walls of churches. Through one window, the hermit observed church services and through another gave spiritual counsel to town citizens. They were fed and cared for by the Church and town in exchange for devoting their life to God and to prayer without any distraction. They then had an obligation to share their wisdom with those who requested spiritual aid. This was a vocation filled by both men and women. Eve of Liège is one such anchoress or hermit.

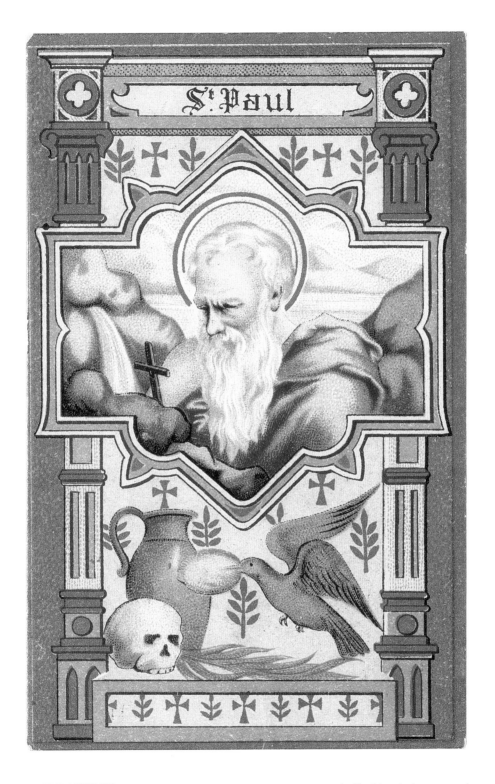

SAINT PAUL THE HERMIT 230–342. Feast Day: January 5. Patron of: Clothing industry workers. Weavers. Paul was from lower Egypt and fled into the desert to avoid religious persecution. He chose a place that had a cave, a palm tree, and a spring. He ate fruit from the tree, drank water from the spring, and wove clothing out of palm leaves. He spent his days in contemplation and is considered the first hermit. A raven would drop a loaf of bread for him. The skull, the raven, and the water jug are now common attributes of all hermits.

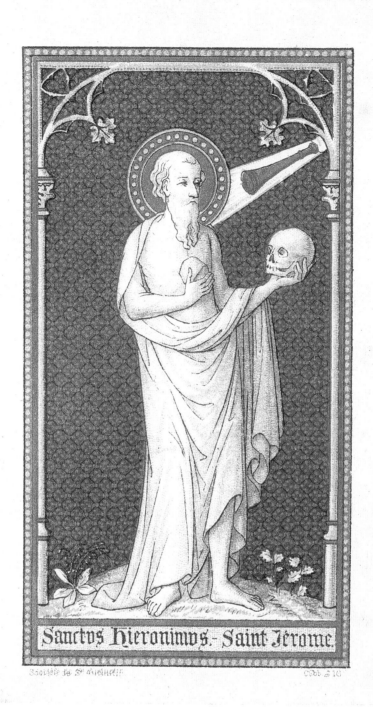

Sanctus Hieronimus.- Saint Jérome.

SAINT JEROME 341–420. Feast Day: September 30. Patron of: Librarians. Archaeologists. Doctor of the Church. After a misspent youth, Jerome became a Christian convert. He lived for years in the Syrian desert, studying and translating biblical texts. He became a priest and worked as secretary to the pope. He spent the last 34 years of his life living in seclusion in the Holy Land, translating the New Testament from Hebrew to Latin. The trumpet from the sky is a symbol of his true calling. He is hitting himself with stone, a symbol of his ascetic lifestyle. The skull is the sign of the penitent.

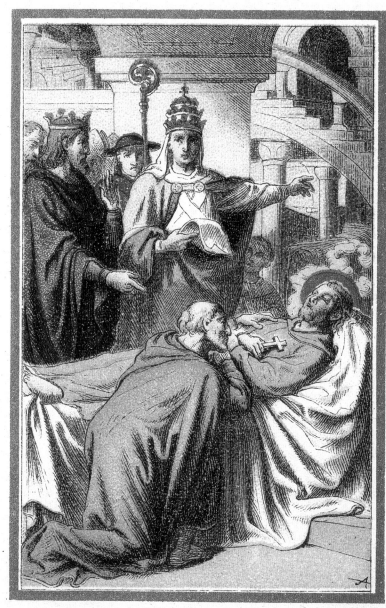

Der heilige Alexius, Bekenner.

SAINT ALEXIS OF ROME Early Fifth century. Feast Day: July 17. Alexis, the son of a Roman senator, fled his wedding to become a beggar. After living in Edessa and earning the reputation for great sanctity, he returned to his home in Rome. His family did not recognize him in his ragged state and allowed him to live under their staircase. By the time of his death, the King (with crown), the Cardinal (in red), and the Pope (with the triple tiara) all recognized his holiness and came to pay him tribute.

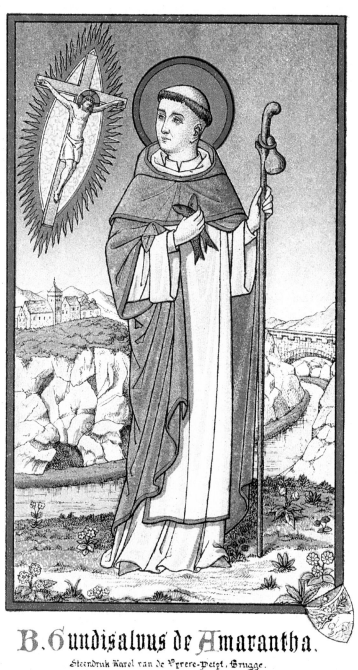

B. Gundisalvus de Amarantha.

Steendruk Karel van de Vyvere-Petyt, Brugge.

BLESSED GUNDISALVUS OF AMARANTE 1187–1259. Feast Day: January 16. Ordained as a priest, Gundisalvus left his wealthy parish to visit the Holy Land. His pilgrimage lasted fourteen years. Upon his return, he went off to Amarante, Portugal, to live as a hermit for the rest of his life, even after joining the Dominican order. As an infant he was enraptured by the crucifix. He has a pilgrim's staff. A bridge he is credited with building is in the background as is the town of Amarante. He holds fish, a sign of Christ, and true believers.

60

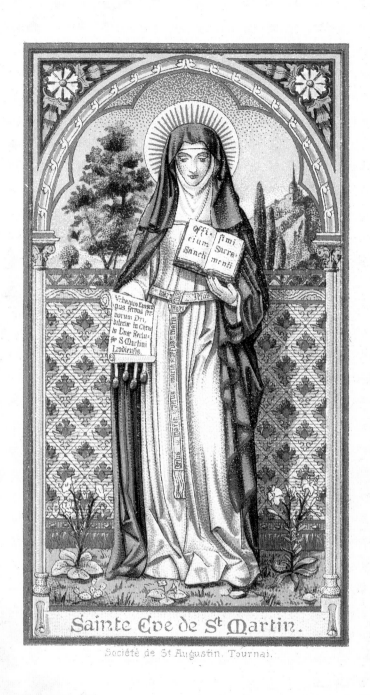

Sainte Eve de St Martin.

Société de St Augustin. Tournai.

BLESSED EVE OF LIÈGE Died 1266. Feast Day: May 26. Eve was a Cistercian nun who lived as a recluse. When Saint Julienne of Cornillon was driven from her convent, she took shelter in Eve's cell. Eve helped her to propagate the Feast of Corpus Christi. Eve holds the Papal Proclamation of the feast and an open book which signifies the widespread celebration of this feast. She has the halo of the Blessed.

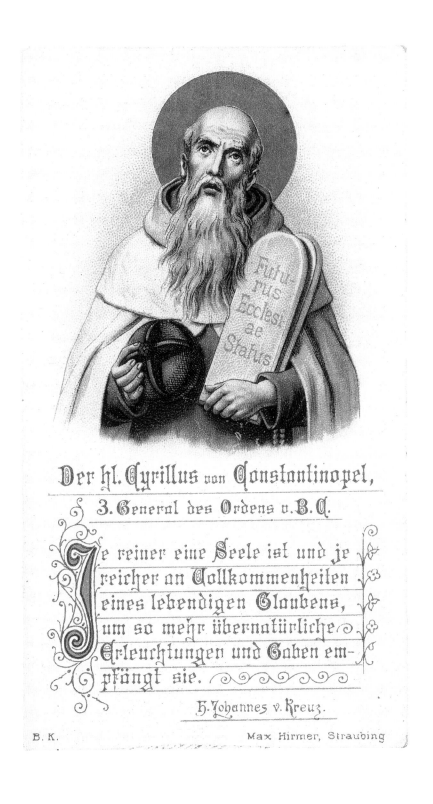

Der hl. Cyrillus von Constantinopel,

3. General des Ordens v. B. C.

Je reiner eine Seele ist und je reicher an Vollkommenheiten eines lebendigen Glaubens, um so mehr übernatürliche Erleuchtungen und Gaben empfängt sie.

H. Johannes v. Kreuz.

B. K. Max Hirmer, Straubing

SAINT CYRIL OF CONSTANTINOPLE 1126–1224. Feast Day: March 6. Born of Greek parents in Constantinople, Cyril became a priest and was known as a gifted teacher. He went to the Holy Land and lived on Mount Carmel in solitude. He is known for his books of prophecy. Cyril holds his tablets of predictions and a prior's hat. This card was issued by the Carmelite order.

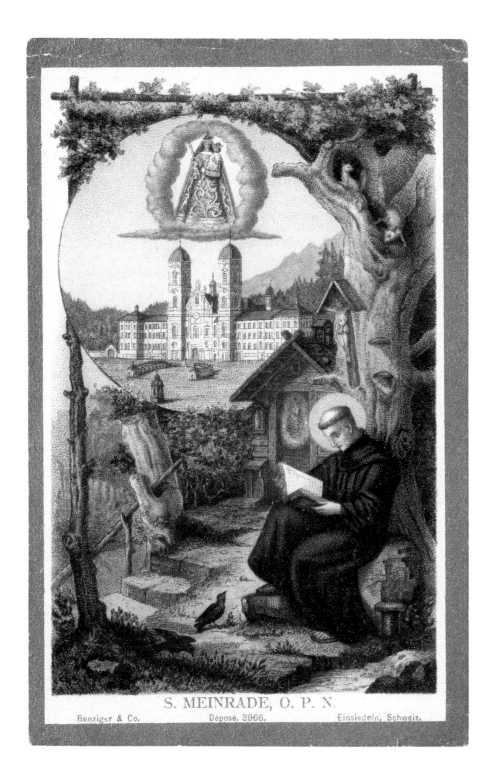

S. MEINRADE, O. P. N.

Benziger & Co. Déposé. 3966. Einsiedeln, Schweiz.

SAINT MEINRAD Died 861. Feast Day: January 21. Patron of: Einsiedeln. Switzerland. Hospitality. Germany. After years of teaching in Switzerland, Meinrad withdrew to a hermitage along the Rhine where he lived alone. Known as an extremely holy man, students would seek him out for his wisdom. He was beaten to death by robbers to whom he gave shelter. The hermitage he built was then used by a series of hermits. In 934, the Benedictine order built a monastery on that spot which is still used to this day. The statue of Mary it houses belonged to Meinrad.

St. Julienne

St. Rita

St. Rose of Lima

St. Gertrude the Great

St. Catherine of Siena

St. Martin de Porres

St. Francis of Assisi

St. Veronica Giuliani

St. Bernadette

St. Bridget of Sweden

St. Mechtild

VISIONARIES
&MYSTICS

St. Gerard Majella

St. Bénézet

St. Margaret Mary Alacoque

St. Peter of Alcantara

St. Thérèse of Lisieux

St. Teresa of Avila

Visionaries and mystics are the living proof of God's grace. Mystics tend to be those who are inclined to devote themselves to prayer or introspection. They are either born with these proclivities or have endured an earth-shattering experience that has completely changed their lives and put them in touch with another dimension of the world. Saint Francis of Assisi led the life of a spoiled noble son until his consciousness was raised by the horrendous realities of warfare. Like him, many mystics develop powers in sync with nature, enabling them to communicate with animals and to sense the inner rhythms of the earth. Some can intuit thoughts of others or channel great works of literature. The stigmata, a copy of the wounds of Christ which sometimes appear, is a physical manifestation of these mysterious communications.

Visionaries are those who see the actual manifestation of a message or messenger. They are not necessarily pious or devout individuals. Saint Bernadette was a simple country girl when she experienced her visions of the Virgin Mary. It was not until the thirteenth visit that she even realized who it was she was communicating with.

In holy cards of these saints they are generally shown experiencing mystical events with the symbols of what these devotions have brought to the world.

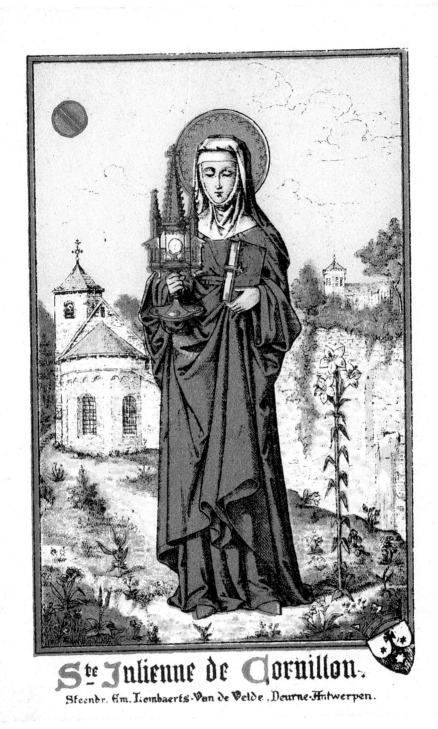

Ste Julienne de Cornillon.

Steendr. Em. Lombaerts·Van de Velde·Deurne·Antwerpen.

SAINT JULIENNE DE CORNILLON 1192–1258. Feast Day: April 5. An Augustinian nun, who with Eve of Liege began the proceeding for the Feast of Corpus Christi. For many years Julienne had a vision of the sun with a black band around it. This symbolized that something was missing from the Church calendar. She is shown with the banded sun, the monstrance holding the body of Christ, her convent in the background, and a closed book of mysterious teaching. A lily is at her side and the Augustinian shield is in the lower corner.

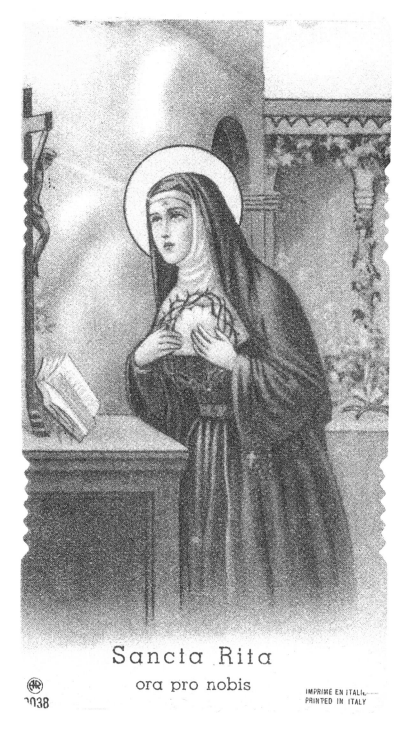

Sancta Rita
ora pro nobis

IMPRIMÉ EN ITALIE
PRINTED IN ITALY

0038

SAINT RITA OF CASCIA 1377–1447. Feast Day: May 22. Patron of: Impossible Causes. Marital Problems. Married to an abusive man who was murdered, Rita tried to join the local Augustinian convent after the death of her two sons. She was refused three times. Saint John the Baptist, Saint Nicholas of Tolentino, and Saint Augustine appeared to her and advised her to try again. She was accepted and became known for the power of her prayers. She meditated on Christ's passion and is shown with a thorn in her head because she begged to feel a part of Christ's suffering. She is always depicted with roses because upon her death, the roses in her garden bloomed off season so that they could adorn her casket.

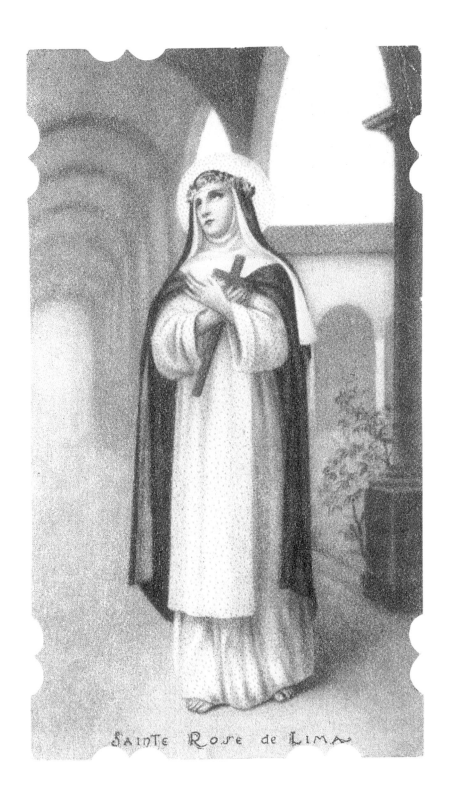

SAINTE ROSE de LIMA

SAINT ROSE OF LIMA 1585–1617. Feast Day: August 30. Patron of: Peru. The Americas. Embroiderers. Florists. Gardeners. A Dominican tertiary known for her great beauty. The first saint of the New World. Despite their objections, she lived as a hermit in her family's garden, praying, growing herbs, and doing embroidery work which she sold to raise money for the poor. She is depicted with a crown of roses clutching a crucifix, which she declared was "the only ladder to get to heaven with."

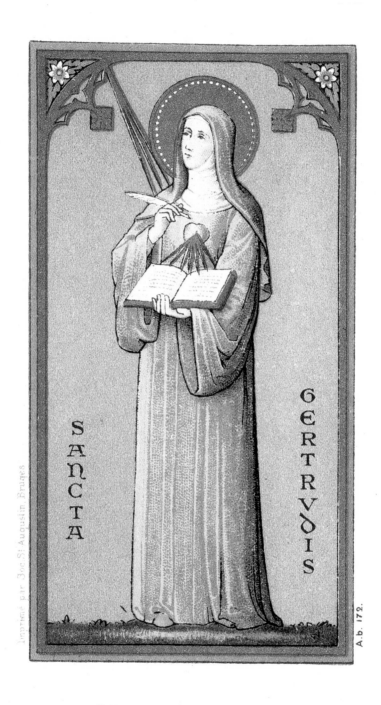

SANCTA GERTRVDIS

Imprimé par Soc. St Augustin, Bruges

A.b. 172.

SAINT GERTRUDE THE GREAT 1256–1302. Feast Day: November 16. Patron of: Nuns. Travelers. Sent to be educated at the monastery of Helfta, Germany, at the age of five, Gertrude never left. She was a great intellectual, devoted to secular philosophy. At the age of 26 she had a vision of Christ and was filled with the realization of the transitory nature of life. Her writings fostered devotion to the sacred heart and detailed her mystical experiences. She is shown holding a pen with an open book as her writings influenced many. Her heart with rays is a reference to the Sacred Heart of Christ. The light of inspiration shines on her from heaven.

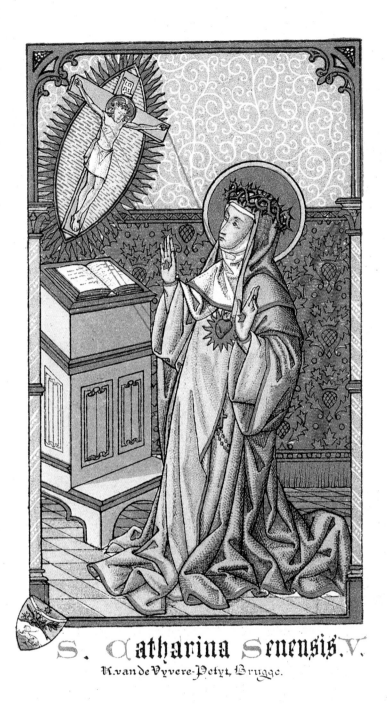

S. Catharina Senensis. V.

R. van de Vyvere-Petyt, Brugge.

SAINT CATHERINE OF SIENA 1347–1380. Feast Day: April 29. Patron of: Italy. Fire Protection. Nurses. Doctor of the Church. A Dominican tertiary, Catherine was known for her spiritual writings as well as her willingness to care for those with the most repulsive diseases. She is shown with the crown of thorns because she received the stigmata. The open book is for her writings, many of which she dictated while in a trance. They are still considered to be great literature and studied to this day.

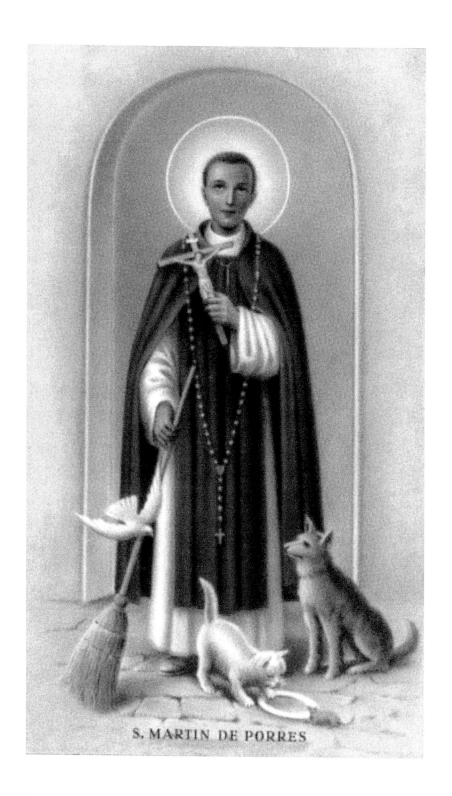

S. MARTIN DE PORRES

SAINT MARTIN DE PORRES 1579–1639. Feast Day: November 3. Patron of: Racial Harmony. The Poor. Barbers. Hairdressers. Half Spanish and half African, Martin was apprenticed to a barber. He was known for his healing abilities and became a Dominican tertiary. He desired to serve God in a state of childlike simplicity. He was in total harmony with nature and the elements and was able to communicate easily with animals. He is shown in his job of sweeping the monastery—the Holy Spirit near him, the dog of faith and fidelity at his feet.

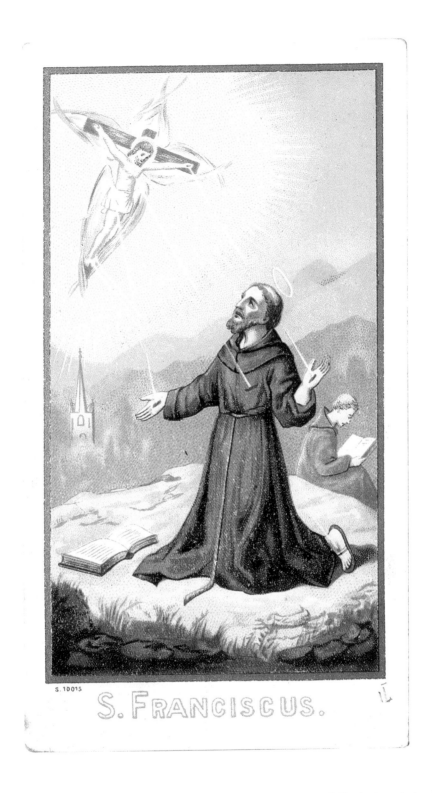

S. 10015

S. FRANCISCUS.

SAINT FRANCIS OF ASSISI 1182–1226. Feast Day: October 4. Patron of: Ecologists. Animals. Nature. Italy. A nobleman's son who totally rejected the material world and tried to live as Christ did, Francis began his own order, the Franciscans. His writings are well known. He is shown in front of an open book, receiving the stigmata. The image of Christ he is communing with is the same as the cross at San Damiano which spoke to him, saying, "Go and repair my house. It is falling down." In the background is the Basilica at Assisi, now a major pilgrimage site.

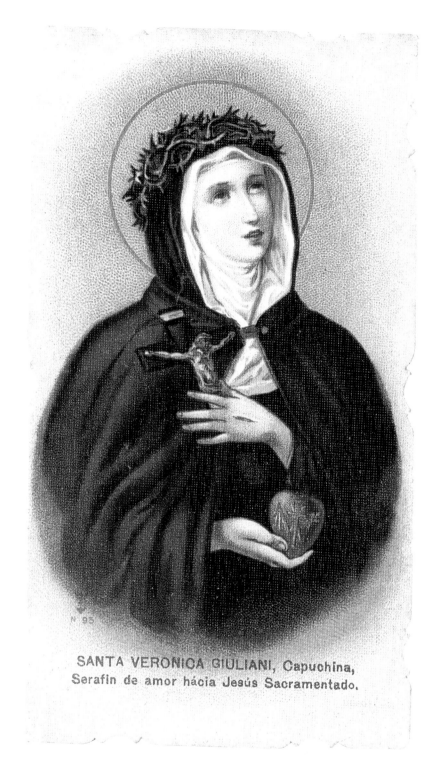

SANTA VERONICA GIULIANI, Capuchina,
Serafin de amor hácia Jesús Sacramentado.

SAINT VERONICA GIULIANI 1660–1727. Feast Day: July 9. A Capuchin nun who became Abbess of her order. She was obsessed with the Passion of Christ from an early age and received the stigmata while rapt in prayer. She suffered an intense pain in her heart and insisted that the symbols of the crucifixion were embedded on it. After her death, surgeons removed her heart and found the symbols of the Passion exactly where she said they were. She is shown holding a crucifix, wearing a crown of thorns, and displaying her heart. Her hands have the marks of the stigmata.

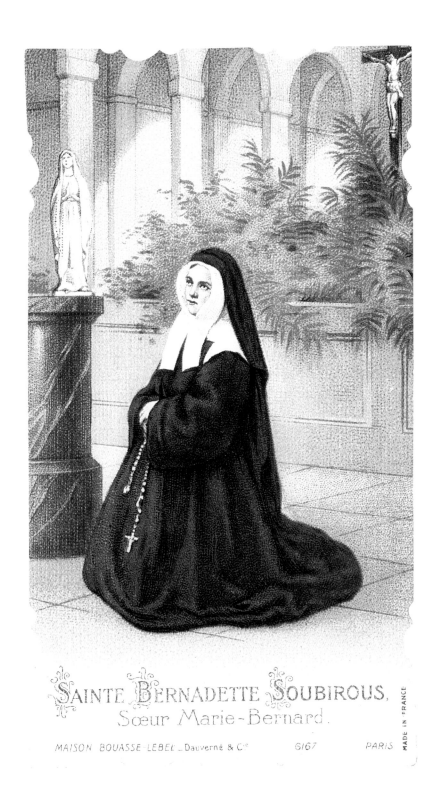

SAINTE BERNADETTE SOUBIROUS,
Sœur Marie-Bernard.

MAISON BOUASSE-LEBEL – Dauverné & C^{ie} 6167 PARIS

MADE IN FRANCE

SAINT BERNADETTE SOUBIROUS 1844–1879. Feast Day: April 16. A poor peasant girl from Lourdes, France, it was her vision of Mary and subsequent communications with her that began the pilgrimage to Lourdes. At Mary's request, she uncovered a hidden spring of water which was proven to have healing powers. Lourdes now attracts over four million pilgrims a year. Bernadette is shown praying with a rosary before a statue of Mary. She wears the habit of the Notre Dame order, the nuns she joined soon after the Marian visitations ended.

ST. BRIDGET OF SWEDEN

SAINT BRIDGET OF SWEDEN 1303–1373. Feast Day: July 23. Patron of: Healers. The daughter of a nobleman, Bridget married a prince. She was widowed and left with eight children after 28 years of marriage. Living at the Swedish Royal Court, she began to experience visions and prophecies directing her to form her own holy order. She began the Bridgettines, a mixed order of monks and nuns. She is wearing the habit that she envisioned and carrying the book of her order. Lilies of purity surround her.

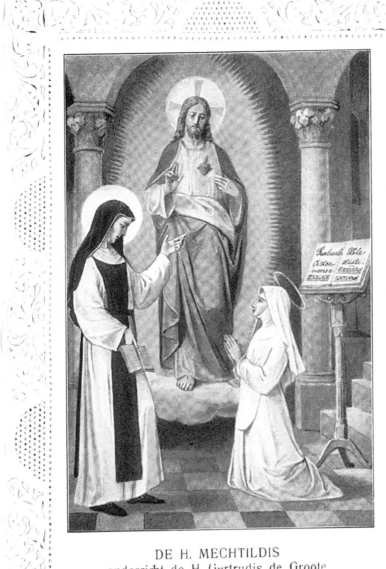

DE H. MECHTILDIS
onderricht de H. Gertrudis de Groote
gest. 1299 Feestdag: 26 Februari.

SAINT MECHTILDE OF HACKEBOURN 1241–1298. Feast Day: November 19. A Benedictine nun; she was entrusted with the care of the child Gertrude. It was her own mystical experiences which inspired Gertrude's *Book of Extraordinary Grace*. She is shown instructing Saint Gertrude as Christ watches them with his heart exposed. A music stand represents Mechtilde's great singing ability.

ST. GERARDUS MAJELLA.

SAINT GERARD MAJELLA 1725–1755. Feast Day: October 16. Patron of: Expectant Mothers. Infertility. Lay Brothers. Because of ill health, Gerard served as a lay brother in the Redemptorist order. Spending his time performing menial tasks and in prayer, he was able to read consciences. Many swore he could be in two places at one time. He is shown in contemplation of the cross with a rosary and lilies for purity.

ST. BÉNÉZET.

Dieu tient l'homme intérieur comme une mère tient la tête de son enfant pour la couvrir de baisers et de caresses.

(Extr. de la Vie du Curé d'Ars.)

Déposé.

SAINT BÉNÉZET 1163–1184. Feast Day: April 14. Patron of: Avignon. Bachelors. A shepherd watching his mother's sheep, Bénézet had a vision during an eclipse. A voice told him to build a bridge over a dangerous part of the Rhone River at Avignon. Thinking it impossible, the church and civil officials ridiculed him and refused to help. He lifted a huge stone in place and announced this would be the foundation. The citizens of Avignon were so inspired by this act, they rushed to help him. The bridge was easily constructed. Bénézet died upon its completion and was buried in the bridge. His incorrupt body was removed in 1669 and reinterred in a church. He is shown in shepherd's robes with the bridge at the bottom of the card.

79

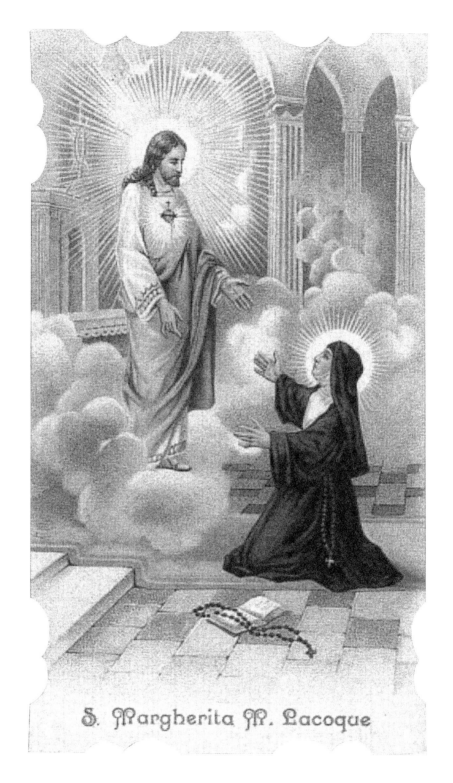

S. Margherita M. Lacoque

SAINT MARGARET MARY ALACOQUE 1647–1690. Feast Day: October 17. Patron of: Polio sufferers. Devotees of the Sacred Heart. Loss of Parents. A Visitation nun who joined the order after being healed by a vision of the Virgin Mary, Margaret Mary Alacoque is known for promoting the devotion to the Sacred Heart. She received a revelation from Christ which included twelve promises to her and to those who practiced this devotion. The open book signifies a widespread teaching; the Sacred Heart, signifying Christ's love and sacrifice for mankind, is prominent on the figure of Christ.

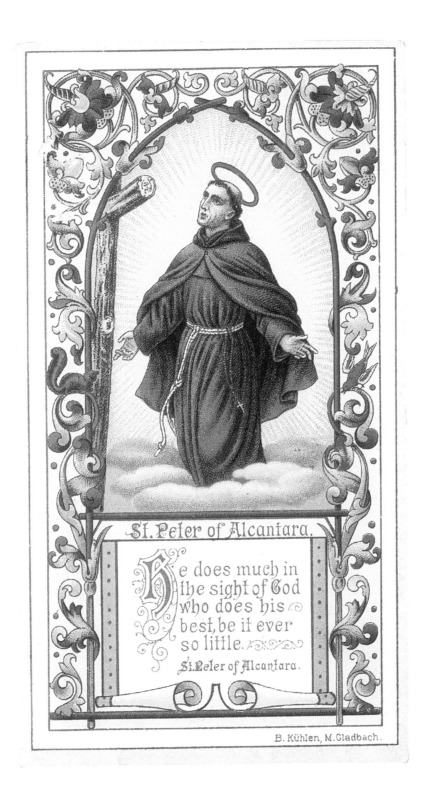

St. Peter of Alcantara.

He does much in the sight of God who does his best, be it ever so little.

St. Peter of Alcantara.

B. Kühlen, M.Gladbach.

SAINT PETER OF ALCANTARA 1499–1562. Feast Day: October 19. Patron of: Brazil. Watchmen. Estremadura, Spain. A Franciscan devoted to reforming his order, Peter was the confessor of Saint Teresa of Avila. He is credited with helping perfect her soul. He dedicated his life to austerity and prayer. He planted crosses wherever he went, often carrying them up great heights. This image is based on the many occasions shepherds witnessed him suspended in midair at the height of the tallest trees in the forest.

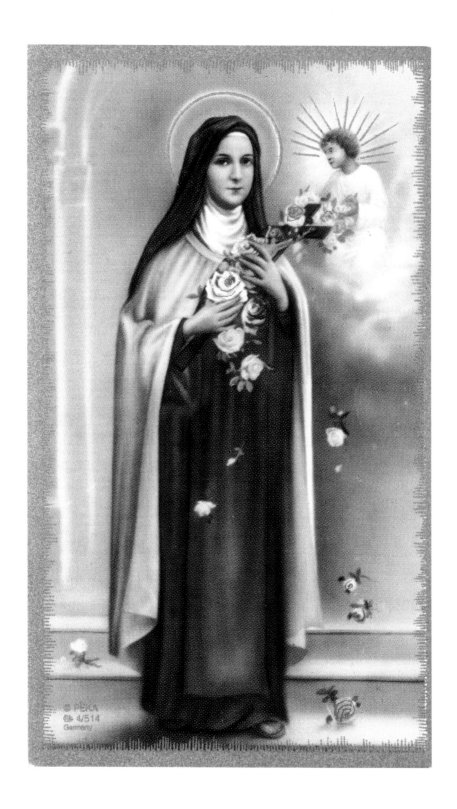

SAINT THÉRÈSE OF LISIEUX 1873–1897. Feast Day: October 1. Patron of: France. Missionaries. Florists. Concerns of Children. A Carmelite nun, Thérèse died at the age of 24 after a simple and prayer-filled life devoted to the Child Jesus. She is depicted in communion with Him, dressed in the habit of her order. Pink and white roses drop because of her promise to "let fall from heaven a shower of roses" to all who invoke her.

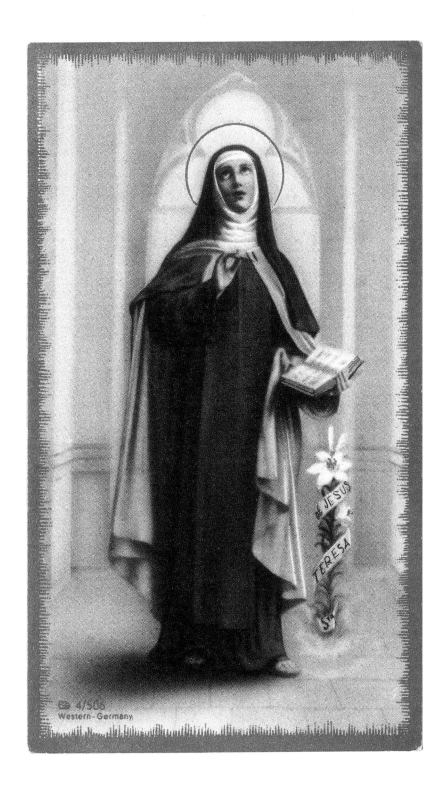

SAINT TERESA OF AVILA 1515–1582. Feast Day: October 15. Patron of: Headache sufferers. Doctor of the Church. One of the greatest writers in church history, Teresa founded the Discalced (shoeless) Carmelites in an attempt to reform her order of nuns. A mystic who experienced many ecstatic experiences, she left an important legacy of written works. She holds an open book because her writings have wide influence. Her hand is held in invitation to God, and the lily is for purity.

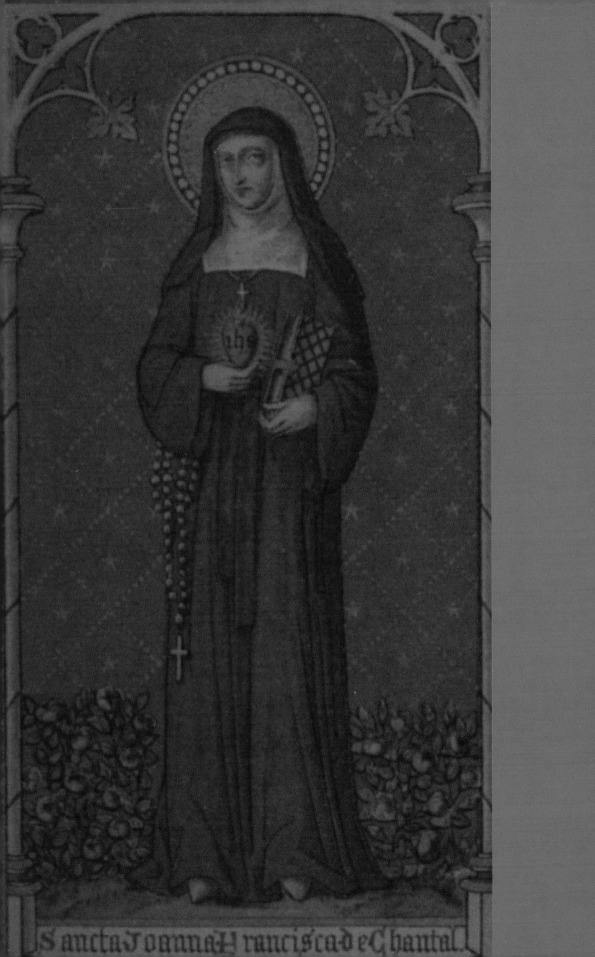

Sancta Joanna Francisca de Chantal.

Bl. Frances D'Amboise

Bl. Mary Bartholomea de Bagnesi

St. Gilbert of Neuffontaines

St. Francis de Sales

St. Jeanne Frances de Chantal

St. Alphonse Liguori

St. Angela Merici

St. Walburga

St. Othilia

St. Anthony of Padua

St. Clare

RELIGIOUS ORDERS

St. Dominic

St. Alanus of Rupe

St. Colette

St. Benedict

St. Frances of Rome

St. Camillus

St. Aloysius Gonzaga

St. Thomas Aquinas

St. Raymund Pennafort

The first monks and nuns lived either as hermits or in small communities cut off from the world. Gradually, under the hand of Saint Benedict, much larger religious communities were formed. Seeking to leave the distractions of the city, these monasteries and convents were built in inaccessible, uncultivated areas. Group labor of the religious order transformed these virtual wastelands into fertile agricultural properties. Towns and villages then developed around the monasteries and convents.

The residents of these religious communities were devoted solely to prayer and they began to copy out religious texts for their own use. Eventually they copied and stored great libraries of ancient philosophy, learning much about architecture, artistic technique, agriculture, medicine, and musical theory. During the many barbaric invasions of the cities, these religious communities have been credited with saving Western civilization by protecting this knowledge.

As Christianity became the main religion in Europe, religious orders devoted to different aspects of that faith became numerous. Orders devoted to education, healing, praying, and missionary work opened in cities, administering to and influencing the general population.

Many of these cards depicting those in the religious orders were created by the individual religious communities from which these saints came.

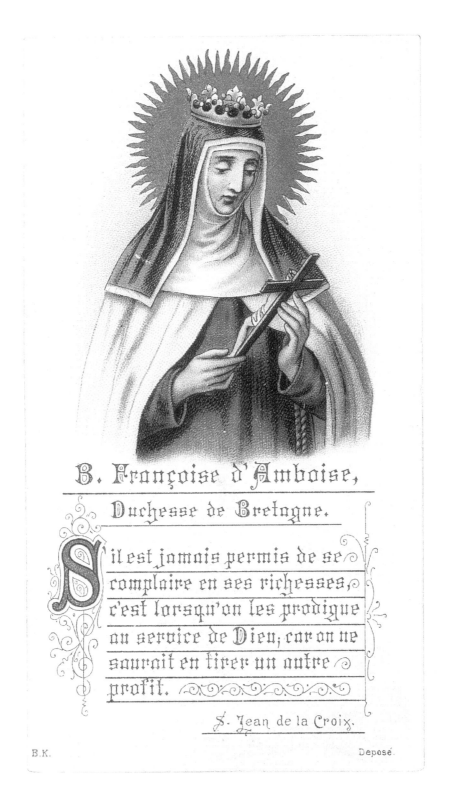

B. Françoise d'Amboise,

Duchesse de Bretagne.

Sil est jamais permis de se complaire en ses richesses, c'est lorsqu'on les prodigue au service de Dieu; car on ne saurait en tirer un autre profit.

S. Jean de la Croix.

B.K.

Déposé.

BLESSED FRANCES D'AMBOISE 1427–1485. Feast Day: November 4. A noblewoman who grew up in the courts of Brittany. She became a nun upon being widowed and is credited with bringing the Carmelite order to Brittany. This is a card created by the Carmelites to honor her. Frances has a crown on her head to denote royal birth. Her halo is that of a Blessed person, not a saint.

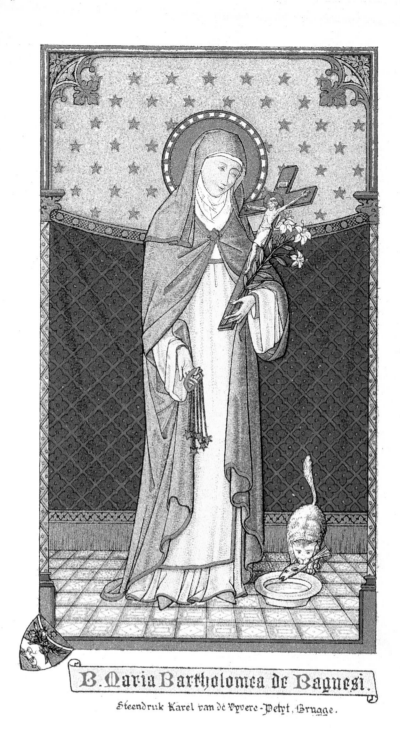

B. Maria Bartholomea de Bagnesi.

Steendruk Karel van de Vyvere-Petyt, Brugge.

BLESSED MARY BARTHOLOMEA DE BAGNESI 1511–1577. Feast Day: May 27. Because of her many physical ailments, Mary Bartholomea led a pained and difficult life as a Dominican nun. Eventually bedridden, her room radiated such peace and calm that it attracted many. Cats especially loved her. She is shown with the halo of the Blessed, a cat drinking the milk of human kindness at her feet. She holds a whip for her life of penance, a cross (the object of her meditations), and lilies for purity.

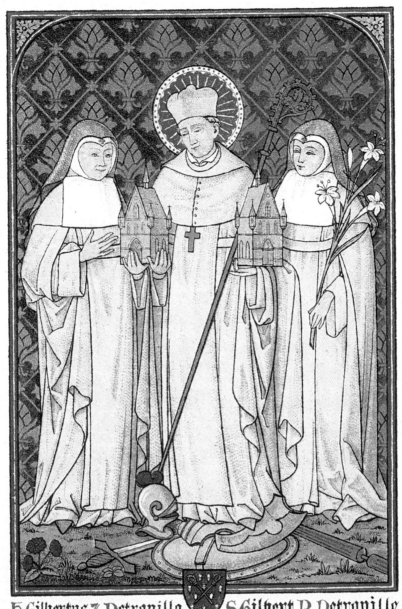

ħ.Gilbertus Z.Petronilla
en hunne dochter Z.Poncia
der orde van Premonstreit

S.Gilbert B.Petronille
et leur fille la Bᵉᵉ Poncia
de l'ordre de Prémontré.

Steendruk Karel van de Vyvere-Petyt . Brugge.

SAINT GILBERT OF NEUFFONTAINES 1076–1152. Feast Day: October 24. Abbot of the
Praemonstratensians in Auvergne. After he returned from the Crusades, Gilbert took up holy orders
along with his wife and daughter. He and his wife Petronilla each started their own separate religious
house which they hold in their hands. While dressed in religious habit, Gilbert holds the staff of an
abbot; his daughter Poncia holds lilies for virginity. His crusader uniform is at their feet with red roses
symbolizing the ardent love of God.

89

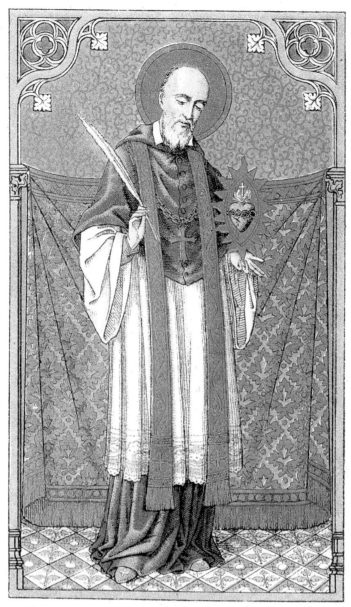

S. Franciscus Salesius

Steend. K. van de Vyvere-Petyt, Brugge.

SAINT FRANCIS DE SALES 1567–1622. Feast Day: January 24. Patron of: Writers. Teachers. Journalists. Educators. The Deaf. Doctor of the Church. Also known as The Gentleman Saint, Francis gave up a brilliant law career to become a priest and eventually bishop. His preaching and written correspondence clearly and simply explained the Catholic faith. He is shown with his pen, contemplating the Sacred Heart, his lifelong inspiration.

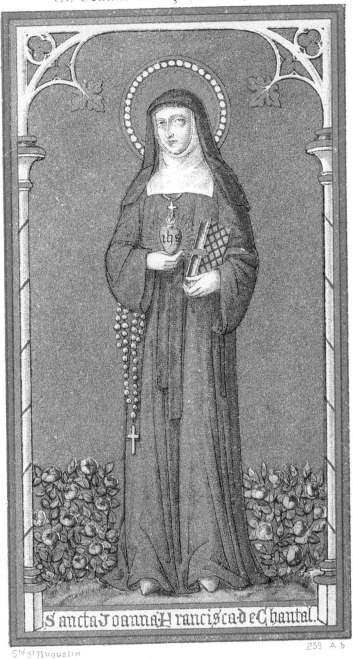

Ste Jeanne-Françoise de Chantal.

Sancta Joanna Francisca de Chantal.

Sté St Augustin 259 A b

SAINT JEANNE FRANCES DE CHANTAL 1572–1641. Feast Day: December 12 (August 18 in U.S.).
Patron of: Those with in-law problems. Widows. A widow with three children, Jeanne heard Francis
de Sales preach and started a correspondence with him. Together, they eventually founded the Visitation
Order of nuns. This order was for widows and lay women who could not devote their full life to the
convent. She is holding the closed book of mysterious teaching in one hand and the Sacred Heart in
the other. She is surrounded by pink roses of heavenly love.

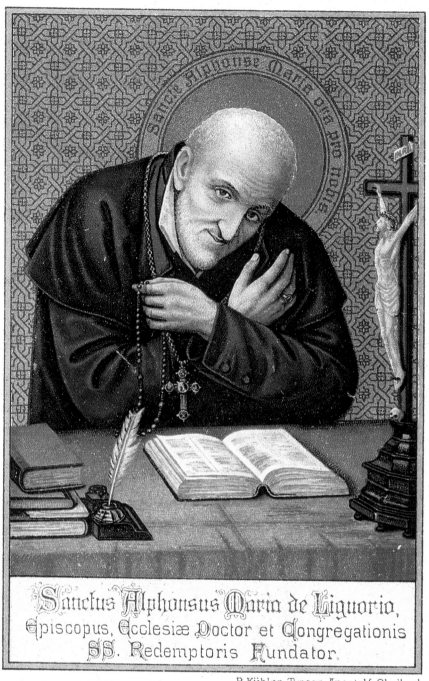

Sanctus Alphonsus Maria de Liguorio,
Episcopus, Ecclesiæ Doctor et Congregationis
SS. Redemptoris Fundator.

B. Kühlen, Typogr. Apost. M. Gladbach.

SAINT ALPHONSUS LIGUORI 1696–1787. Feast Day: August 1. Patron of: Arthritis sufferers. Pains of old age. Doctor of the Church. Founder of the Redemptorist order. Despite being crippled with arthritis, Alphonse Liguori published over 60 books and wrote poetry and music as well. His sermons were understood by even the least sophisticated. His multitude of writings are represented by the open book, he has the pectoral cross denoting a bishop, and he is always hunched over with arthritis.

Die hl. Angela Merici, Ordensstifterin.

Dép. 3928

SAINT ANGELA MERICI 1474–1540. Feast Day: January 27. Patron of: The Handicapped. The Physically challenged. Foundress of the Ursuline Order of Nuns. A talented teacher, Angela had visions of Saint Ursula saving young girls. She was inspired to do the same by starting a girls' school. She named her order of nuns after the saint. She is shown having a vision, the open book indicative of an educator who spreads knowledge.

S. Walburga

2085

CASM

SAINT WALBURGA 710–779. Feast Day: February 25. May 1. Patron of: Cough sufferers. Famine. Storms at sea. Antwerp, Belgium. The daughter of one of the Saxon kings, Walburga was born in Wessex, England. As a Benedictine nun she moved to Germany where she became Abbess of several religious communities of men and women. She wears a crown denoting her royal birth and holds the Abbess's staff. In her hand is the closed book of mysterious knowledge. On the book and at her feet are flasks of the oil which still oozes at her shrine and is reputed to have curative powers.

94

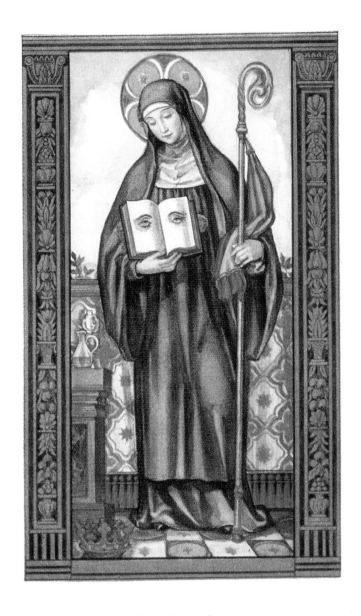

S. Othilia

2085 CASM

SAINT OTHILIA 660–720. Feast Day: December 13. Patron of: Alsace. Othilia was born blind into a noble family. She was expelled from her home and given to a peasant family to raise. At the age of twelve she was taken in by the local convent and miraculously regained her sight as she was being baptized. She became Abbess of her convent and is shown holding a staff. In her hand is a book with eyes, signifying her returned sight, and at her side are the holy oils of baptism.

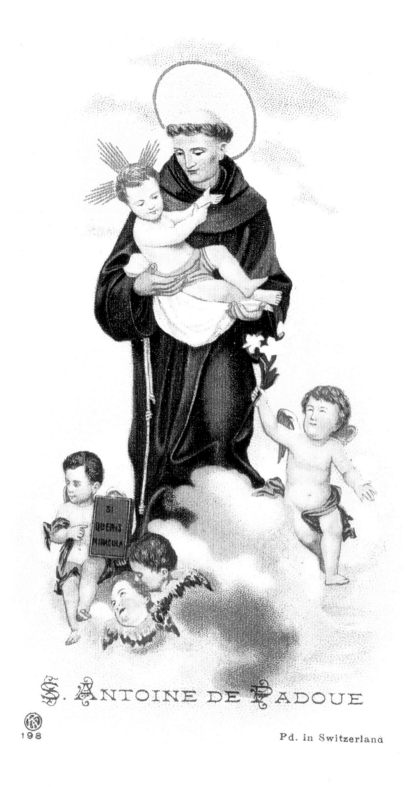

S. ANTOINE DE PADOUE

198

SAINT ANTHONY OF PADUA 1195–1231. Feast Day: June 13. Patron of: Lost Articles. Those in Debt. Portugal. A Franciscan friar known for his extraordinary preaching ability, he is also known as "The Wonderworker." He is always shown with the baby Jesus because an uncle once saw Anthony laughing and playing in the garden with an infant who kissed him, then disappeared. The angels hold the psalter that was stolen then returned to Anthony after praying for it.

St. Clare.

M. H. W. C?

SAINT CLARE 1194–1253. Feast Day: August 11. Patron of: Television. Needle workers. Gold workers. Founded the Community of Poor Clares with Saint Francis of Assisi. A rich girl, who was inspired to live like Saint Francis and his followers, Clare is always shown with a monstrance. This is because when her convent was once attacked, she went outside holding a monstrance with a host in it. The attackers immediately dispersed. Lilies for purity are in front of her and the town of Assisi is behind her.

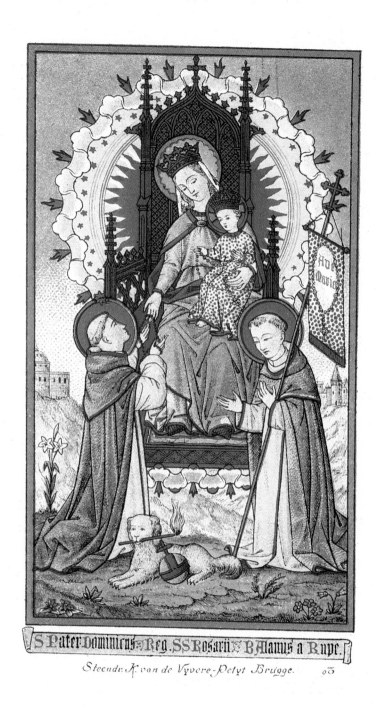

S Pater Dominicus ⦁ Reg. SS Rosarii ⦁ B Alanus a Rupe.

Steendr. K. van de Vyvere-Petyt Brugge. 93

SAINT DOMINIC AND SAINT ALANUS OF RUPE Dominicans from two different centuries. Both were devoted to the rosary. Saint Dominic started the Dominican order. His attributes are a dog with a torch. Before giving birth, his mother had a dream with that image. His preaching later set the world on fire. His devotion to the rosary began when he had a vision of the Virgin Mary asking him to say the rosary and teach it wherever he went. Two hundred years later, Saint Alanus also had a special devotion to the rosary and is credited with greatly increasing its popularity.

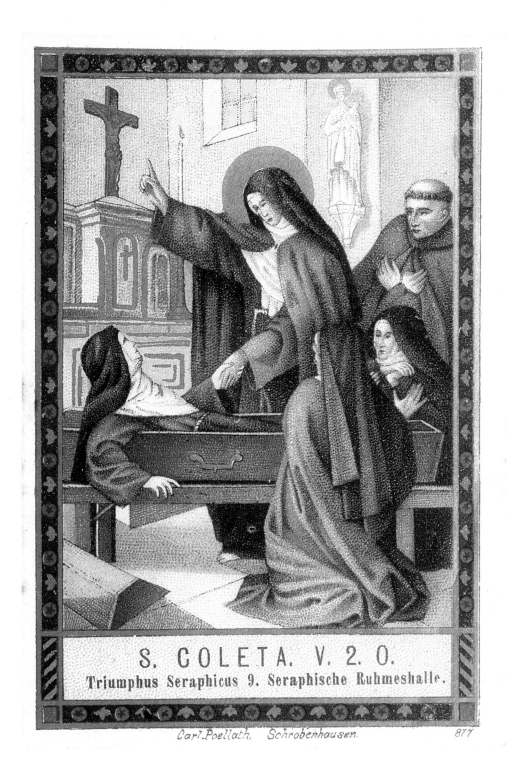

S. COLETA. V. 2. O.
Triumphus Seraphicus 9. Seraphische Ruhmeshalle.

Carl.Poellath, Schrobenhausen. 877

SAINT COLETTE 1381–1447. Feast Day: March 6. Patron of: Loss of Parents. After being orphaned at age 17, Colette lived an austere existence as a Franciscan tertiary. Saint Francis appeared to her and asked that she restore and reform the Order of the Poor Clares. She gradually became well known and respected for piety and mystical powers. She founded seventeen more convents. Many times accused of sorcery, she is shown raising a nun from the dead. This can also be a pictorial reference to her work in revitalizing the Poor Clares.

99

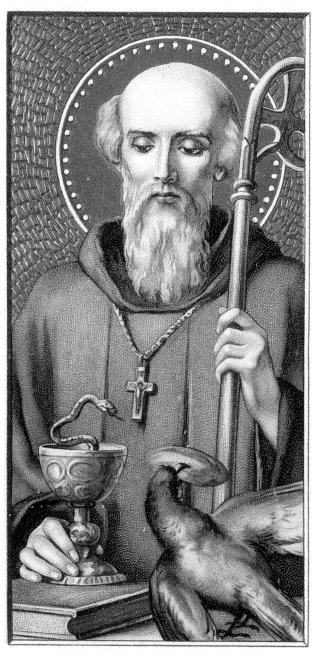

ST. BENEDICTUS.

SAINT BENEDICT 480–547. Feast Day: July 11. Patron of: Monks. Founder of the Benedictines. He is the father of Western Monasticism, most monks still follow his rule. Living as a hermit when he founded his order, a raven with bread offers him sustenance. He holds the Abbot's staff. Jealous monks once tried to poison his wine; the snake of Satan is lurking in the chalice. The closed book is for mysterious teachings. Benedict was known for his supernatural gift of prophecy.

ST. FRANCISCA ROMANA.

SAINT FRANCES OF ROME 1384–1440. Feast Day: March 9. Patron of: Motorists. Widows. An aristocratic Roman, Frances was married for 40 years. When her husband was driven out of the city due to political turmoil, Frances's prayers were not only rewarded with his safe return but she also received the gift of healing and the ability to see her guardian angel. She founded a house for Benedictine Oblates dedicated to caring for the poor. She joined the community herself when she was widowed. She holds the whip of the penitent, signifying the change of her lifestyle.

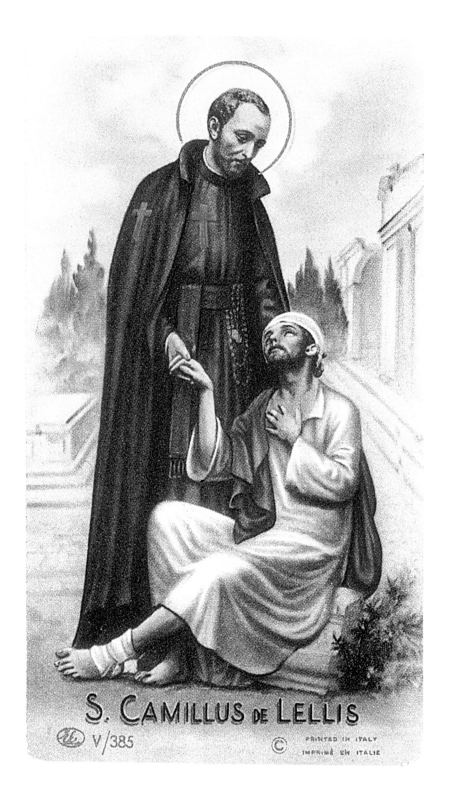

S. CAMILLUS DE LELLIS

V/385 © PRINTED IN ITALY
IMPRIMÉ EN ITALIE

SAINT CAMILLUS DE LELLIS 1550–1614. Feast Day: July 14. Patron of: Nurses. Those with bodily ills. A soldier with a gambling habit, Camillus was forced to work in construction to pay off debts. He was converted by the Capuchins for whom he was working. After spending time in a hospital for an incurable war injury, Camillus was inspired to devote his life to caring for the sick. He founded the Congregation of the Servants of the Sick, a nursing order which was later named for him. The red cross is his attribute.

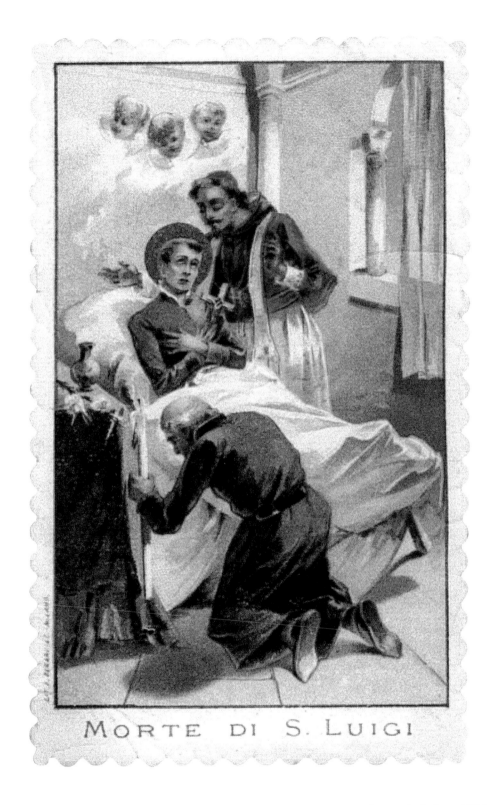

MORTE DI S. LUIGI

SAINT ALOYSIUS GONZAGA 1568–1591. Feast Day: June 21. Patron of : AIDS victims. AIDS care-givers. Teenagers. He grew up in a castle and was trained as a soldier and courtier from the age of four. A kidney infection left Aloysius bedridden, with much solitary time spent in prayer. At the age of eighteen he became a Jesuit novice, signing his inheritance away to his family. He tended plague victims in Rome before dying of the plague himself.

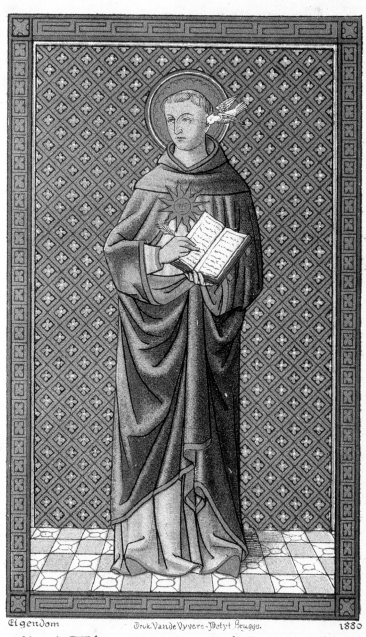

Eigendom Druk. Van de Vyvere-Petyt Brugge. 1880

Stos. Thomas Aquinas, Eccl. doct.

SAINT THOMAS AQUINAS 1225–1274. Feast Day: January 28. Patron of: Students. Universities. Catholic Schools. Doctor of the Church. This Dominican priest is considered one of the greatest thinkers and writers of the Middle Ages. He holds a pen to an open book signifying his widespread writings. The holy spirit is at his ear because the writings were divinely inspired. His greatest attribute is the sun of truth on his breast.

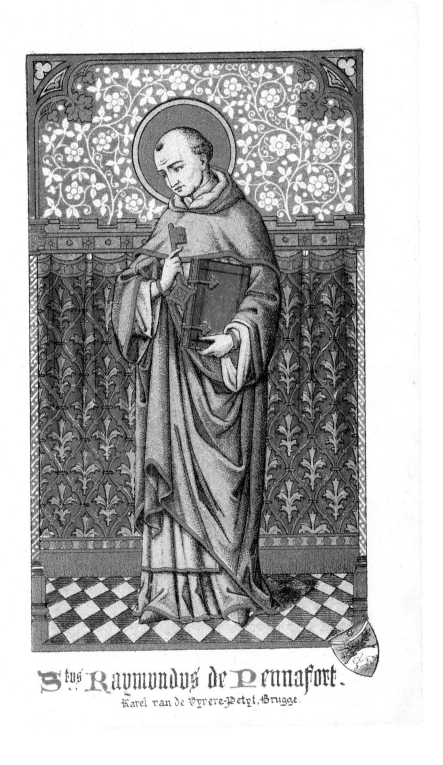

Sᵗᵘˢ Raymondus de Pennafort.

Karel van de Vyvere-Petyt, Brugge.

SAINT RAYMUND PENNAFORT 1175–1275. Feast Day: January 7. Patron of: Law schools. Lawyers. A professor of law who joined the Dominican order at the age of forty-seven, Raymund is best known for codifying Canon Law. Priests today still follow his list of penances to be meted out in the sacrament of reconciliation. He holds a key representing the spiritual powers of confession and absolution and the closed book of hidden knowledge.

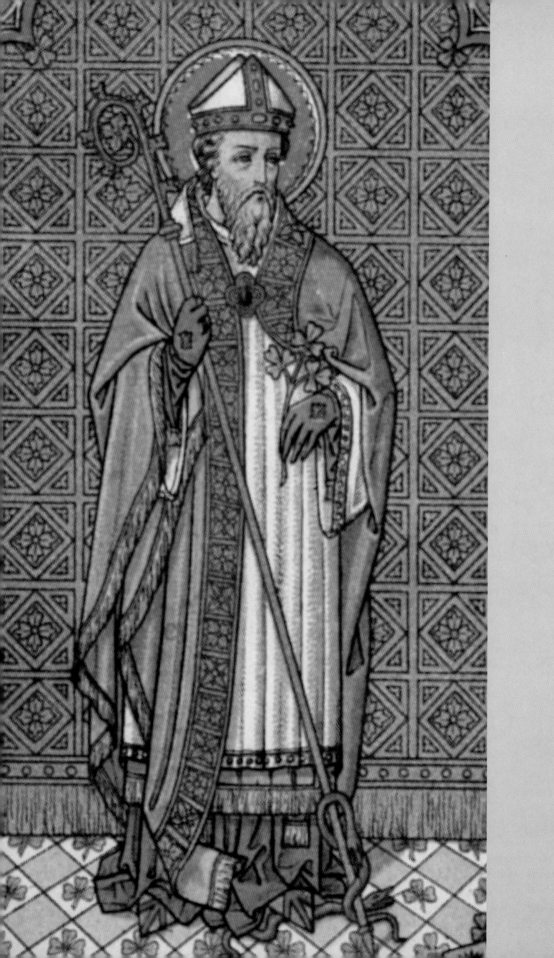

St. Francis Borgia

St. Patrick

St. Swithbert the Elder

St. Leonardo of Port Maurice

Bl. Marie of the Incarnation

St. Francis Xavier

St. Frances Xavier Cabrini

St. Hyacinth

MISSIONARIES

After the Ascension of Christ, His apostles and disciples spread to every corner of the world evangelizing. Then, as now, the people most affected by the labors of missionaries are the poorest and the least important members of society. The work of Saint Patrick, who was the great evangelist of Ireland, has had an impact on the world that he could never have imagined, as the Irish have migrated all over the world, taking their faith with them.

Monks who built their monasteries in remote corners of Ireland, England, and Northern Europe converted the local population by the example they set in the way they lived. There later followed a tradition of traveling preachers from these orders who introduced Christian teachings in villages that had no churches. Later, in other parts of Europe, the Franciscans and the Dominicans went from town to town preaching in public squares to all who would listen.

The first foreign missions were formed to minister to Catholics who had moved to non-Christian countries. When Saint Francis Xavier went to Goa, India, to work for the Portuguese settlers there, it was the local, lower-caste Indians who were most inspired by him.

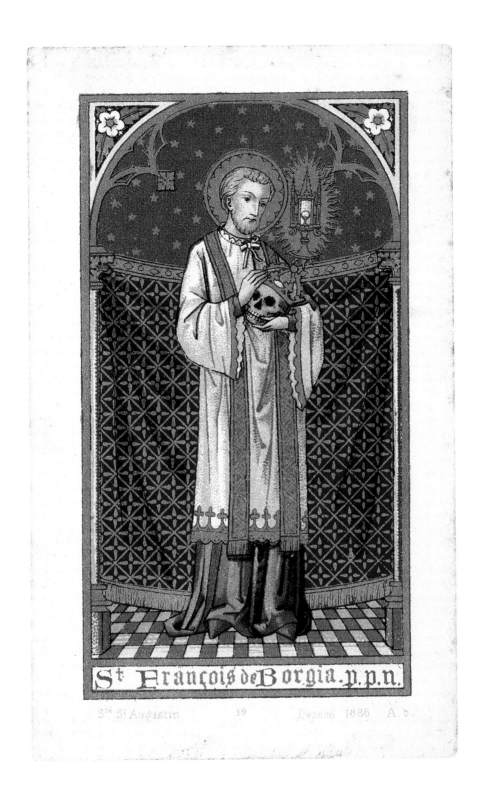

St François de Borgia. p.p.n.

Sté St Augustin 19 Deposé 1886 A.b.

SAINT FRANCIS BORGIA 1510–1572. Feast Day: October 10. Patron of: Earthquake Prevention. Portugal. An important figure in the Counter Reformation, Francis Borgia was a widower with eight children when he joined the Jesuit order. He began missions in the Americas and established the Jesuits in Poland. He was a penitent and from nobility, therefore he holds a skull with a crown. Since he is considered a savior of the church, there is a monstrance with the host above him.

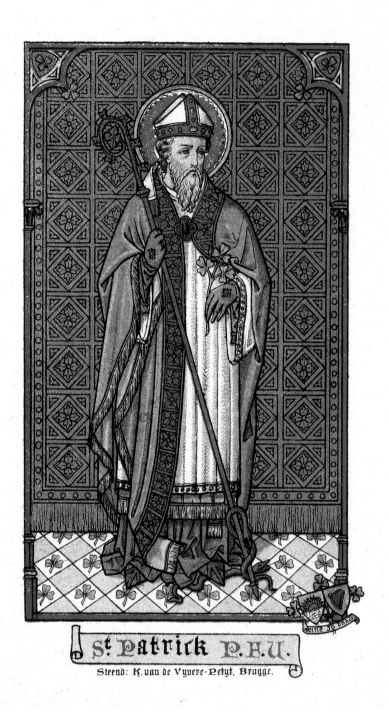

St. Patrick P.F.U.

Steend: K. van de Vyvere-Petyt, Brugge.

SAINT PATRICK 389–461. Feast Day: March 17. Patron of: Ireland. Fear of Snakes. Nigeria. Credited with almost single-handedly converting the entire Irish nation, Patrick is depicted with a bishop's mitre and staff. His attribute is the shamrock which he used as a tool to teach about the Holy Trinity. Snakes represent false teachings, and Patrick was known for driving the snakes out of Ireland.

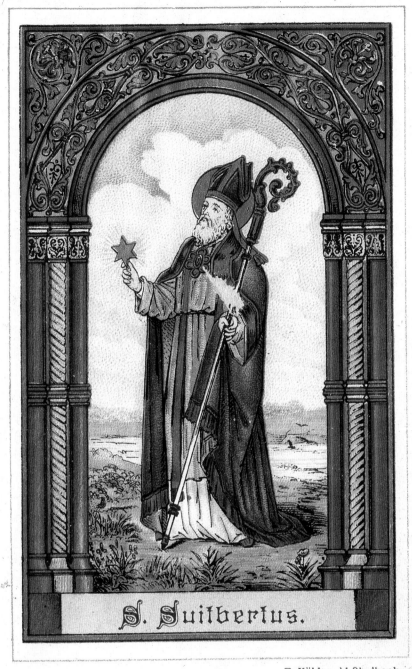

S. Suitbertus.

SAINT SWITHBERT THE ELDER 647–713. Feast Day: March 1. Patron of: Angina sufferers. Germany. Throat disease. Born in England, Swithbert was a Benedictine monk sent to work in southern Germany. He evangelized much of northern Italy and built a Benedictine monastery on the Rhine. He is depicted in Bishop's garb with a star of the energy of Christ on his fingertips. The Rhine is in the background.

111

S. LEONARDO DA

PORTO MAURIZIO

STAB. A. MARZI·ROMA

SAINT LEONARDO OF PORT MAURICE 1676–1751. Feast Day: November 26. A Franciscan monk who was a great preacher, Leonardo of Port Maurice inspired thousands in many different regions of Italy. His special devotion was to the Stations of the Cross. He literally died of exhaustion at his monastery of Saint Bonaventure in Rome. This card is from that church where his remains are kept in the altar.

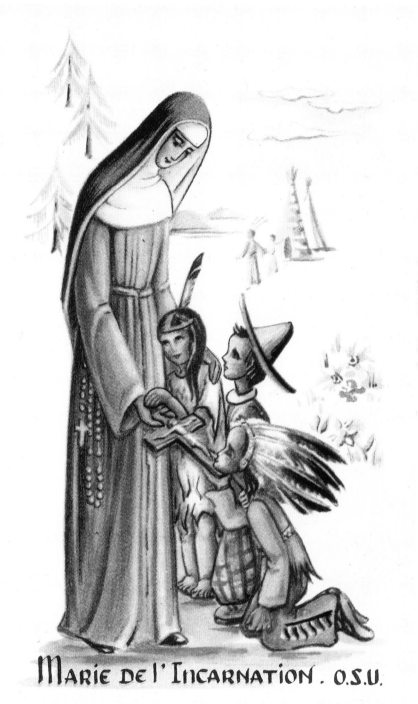

MARIE DE l' INCARNATION . O.S.U.

BLESSED MARIE OF THE INCARNATION 1599–1672. Feast Day: April 30. Marie was a widow who joined the new Ursuline order in France when her son turned twelve. She founded the Ursuline convent in Quebec, Canada, in 1639. She worked with young Indian and French settlers' children for the next thirty three years. Her writings are important records of the harsh existence of the first Europeans in Canada.

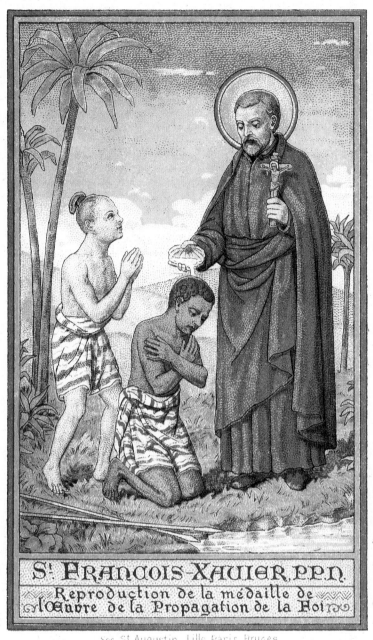

St. FRANÇOIS XAVIER. P.P.N.

Reproduction de la médaille de
l'œuvre de la Propagation de la Foi

Soc. St Augustin, Lille, Paris, Bruges

SAINT FRANCIS XAVIER 1506–1552. Feast Day: December 3. Patron of: Foreign Missions. Considered the greatest Christian missionary, Francis Xavier was a wealthy Basque nobleman who was one of the first eight Jesuits. He was based in Goa, India, administering to the Portuguese colony. His great devotion gave him the gift of tongues, enabling his preaching to reach and to convert tens of thousands of poor Indians subjugated under the caste system. He worked extensively and successfully in Japan and died on his way to China.

SAINT FRANCES XAVIER CABRINI 1850–1917. Feast Day: November 13. Patron of: Immigrants. Hospital Administrators. Orphans. Displaced Persons. Founder of the Missionary Sisters of the Sacred Heart. Though it was her dream to open missions in Asia, the Church sent Frances Cabrini to New York City to administer to the Italian immigrant community. The poor of all religious backgrounds benefited from her labors as she opened schools, hospitals, and orphanages in several American cities. She became a naturalized American citizen and is the first canonized saint from the United States.

116

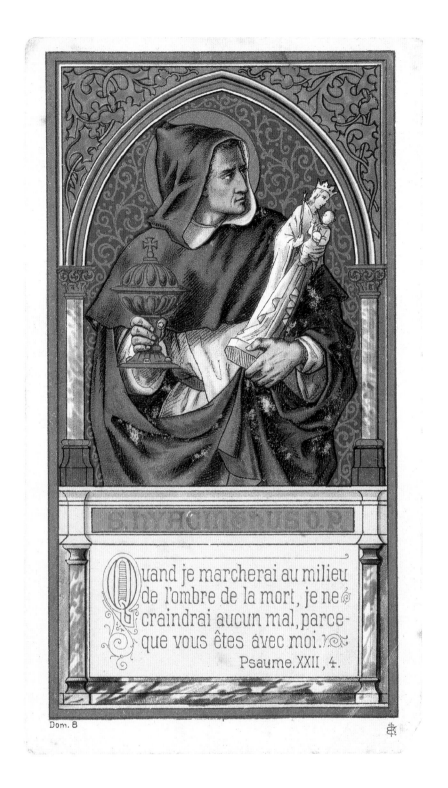

Quand je marcherai au milieu de l'ombre de la mort, je ne craindrai aucun mal, parce-que vous êtes avec moi.

Psaume. XXII, 4.

Dom. 8

SAINT HYACINTH 1185–1257. Feast Day: August 17. Patron of: Lithuania. Called the Apostle of the North, Hyacinth was a Dominican priest who received his habit from Saint Dominic. His missions extended from Poland, through Scandinavia, Eastern Europe, and parts of Russia. When Kiev was being sacked by the Tartars, Hyacinth safely led his followers through the ranks of the marauders by holding up the ciborium which held the host and an alabaster statue of the Virgin Mary which had cried out to him for rescue.

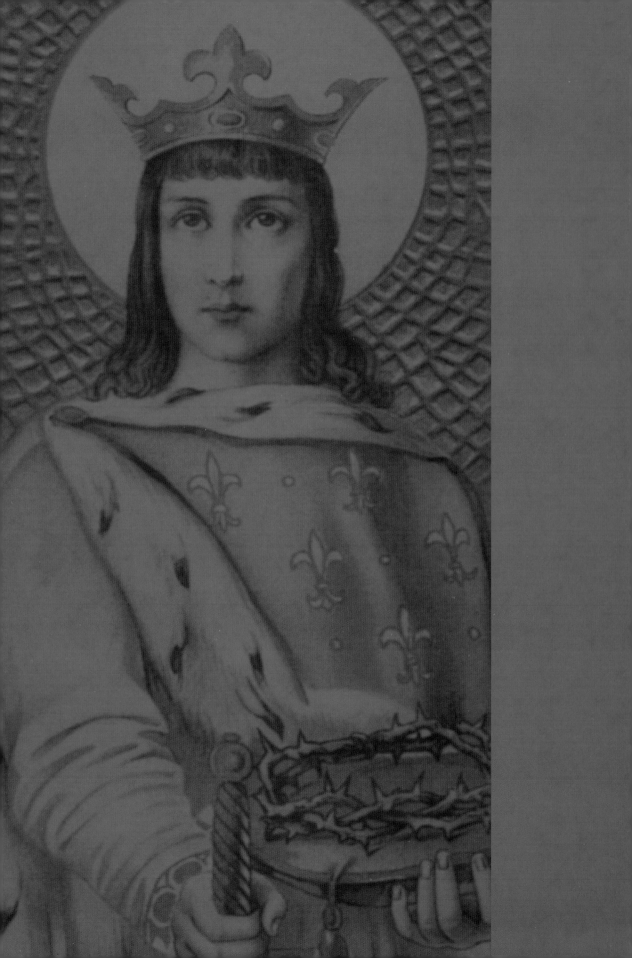

HOLY PEOPLE

St. Joan of Arc

St. Monica

St. Liberata

St. Zita

St. Nicholas

St. Anne

St. Sofia

St. Joseph

St. Helena

St. Louis

St. Charles Borromeo

St. Jerome Emiliani

St. Roch

St. Veronica

Jesus Christ

The Virgin Mary

The saints come from all ages and all walks of life. They can be humble servants like Saint Zita or born to nobility as was King Louis of France. When Saint Joan of Arc was counseled by her voices, she merely did what they told her to do, even though it made very little rational sense. All of the saints experienced their religion in the truest sense and changed the world by living their lives.

The holy people who make up this section were not forced to act in any way to defend their faith, as were the martyrs. It was not necessary for them to withdraw from the world, join religious orders, or spend their days in prayer. Rather, they went on with their day to day existence, humbly accepting the roles they were given.

"Ecce Homo" is a depiction of Christ in all His humanity when He felt the most betrayed by and sorrowful for those whom He wanted to save. This image is great comfort to those who feel despair, knowing that a complete transformation of spirit, like Christ's Ascension, is inevitable.

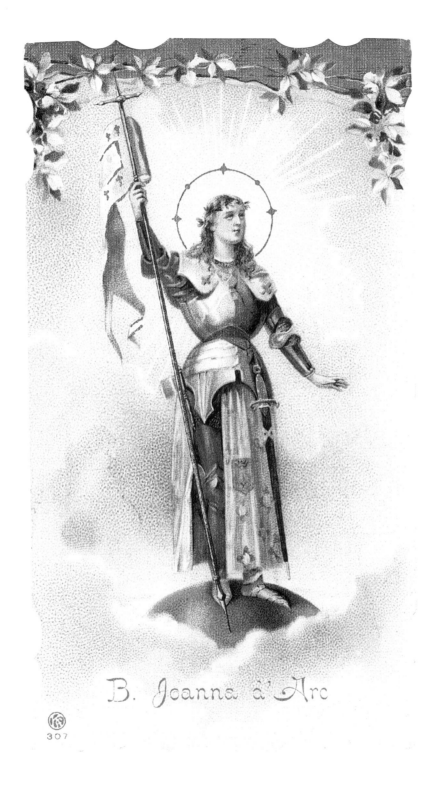

B. Joanna d'Arc

SAINT JOAN OF ARC 1412–1431. Feast Day: May 30. Patron of: France. Soldiers. Captives. A mystic with the gift of prophecy, Joan was a young French peasant girl who was counseled by three voices, Michael the Archangel, Margaret of Antioch, and Catherine of Alexandria. Using their guidance she was able to inspire the French to free themselves from British domination. She is shown with her banner reading "Jesus Mary," with which she led troops into battle. She is surrounded by lilies for purity. This card was made before she was declared a saint and was still a Blessed.

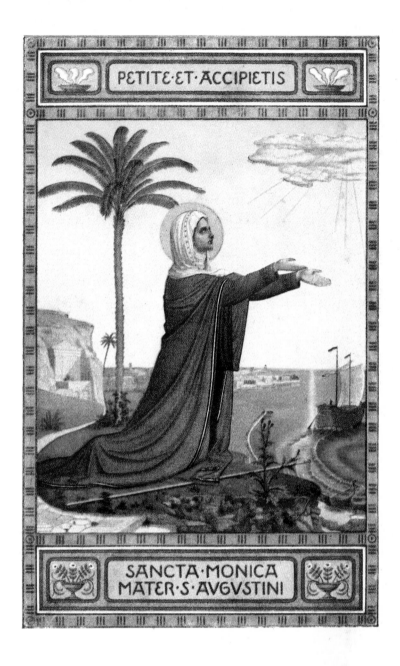

PETITE·ET·ACCIPIETIS

SANCTA·MONICA
MATER·S·AVGVSTINI

K. BEURON 1027 MADE IN GERMANY

SAINT MONICA 322–387. Feast Day: August 27. Patron of: Those with disappointing children. Alcoholics. From Tagaste in North Africa, Monica is best known as the mother of Saint Augustine. Though he lived a dissolute life and did not share her beliefs, she never wavered in her prayers for him. She is shown bidding him goodbye, her hands open in supplication as the Holy Spirit showers his boat with grace. The pilgrim's staff is at her side.

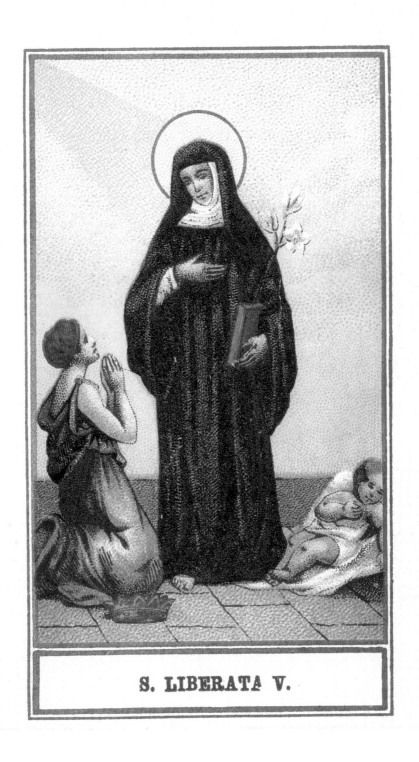

S. LIBERATA V.

SAINT LIBERATA Fifth century. Feast Day: January 16. Liberata was a holy woman who consecrated herself to private vows. She was known for her goodness to the sick and poor. She is shown being showered by the grace of the Holy Spirit, holding a lily for purity and the closed book of inner knowledge. A person inspired to prayer is on one side of her, while a sick person lies on the other.

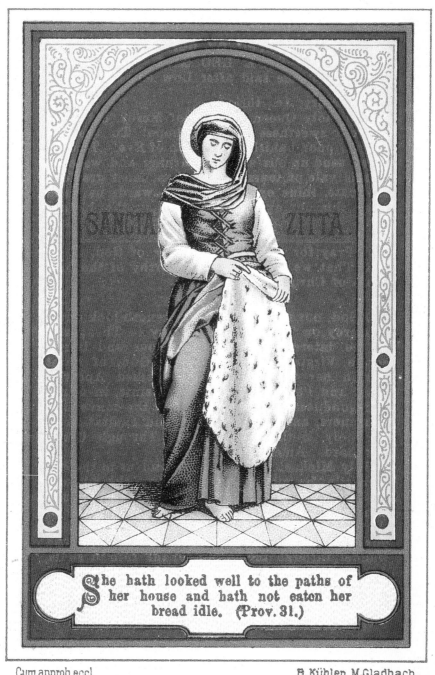

SANCTA ZITTA.

She hath looked well to the paths of her house and hath not eaten her bread idle. (Prov. 31.)

Cum approb. eccl.

B. Kühlen, M.Gladbach.

SAINT ZITA 1218–1278. Feast Day: April 27. Patron of: Servants. Those who lose their keys. From Lucca, Italy, Zita was a domestic servant known for her charity and mystical experiences. When she gave her master's fur coat to a beggar, an angel returned it to her the next day. She is always shown wearing an apron. In this card she holds the returned fur.

124

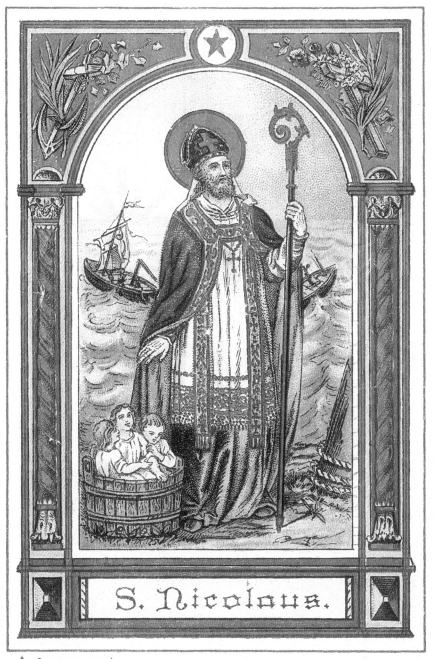

S. Nicolaus.

SAINT NICHOLAS Died c. 350. Feast Day: December 6. Patron of: Children. Sailors. Bakers. Russia. Sicily. Nicholas was a Turkish bishop from Myra known for his kindness and ability to work wonders. He prayed over a ship in a fierce storm, calming the sea, and for this he is the patron of sailors. The three boys in a bucket were murdered by a butcher during a famine and pickled in brine. Nicholas was able to return them to life. The star of the Epiphany and energy of Christ is over his head.

125

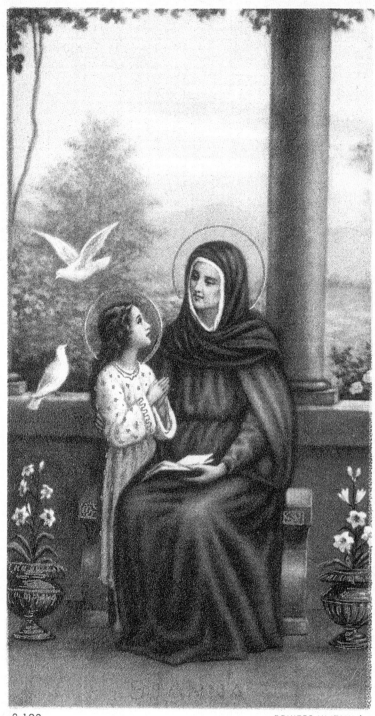

3-193

SAINT ANNE First century B.C. Feast Day: July 26. Patron of: Brittany. Canada. The Infertile. Cabinet makers. After 20 years of barrenness, Anne became the mother of the Virgin Mary. She is always shown teaching her daughter with the open book of universal knowledge, while doves representing the Holy Spirit hover over Mary. Lilies grow as a sign of Mary's purity.

126

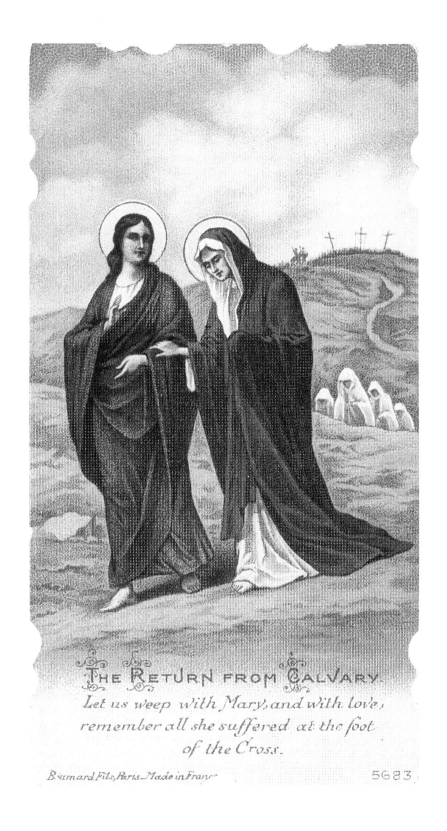

THE RETURN FROM CALVARY

Let us weep with Mary, and with love,
remember all she suffered at the foot
of the Cross.

Boumard Fils, Paris—Made in France

5683

THE RETURN FROM CALVARY The Virgin Mary is supported by Saint John as they leave the scene
of Christ's crucifixion. Three crosses are on the hill in the far background. Though the scene is one of
hopelessness and sorrow, shrouded figures of the spiritual world watch over them in the background.

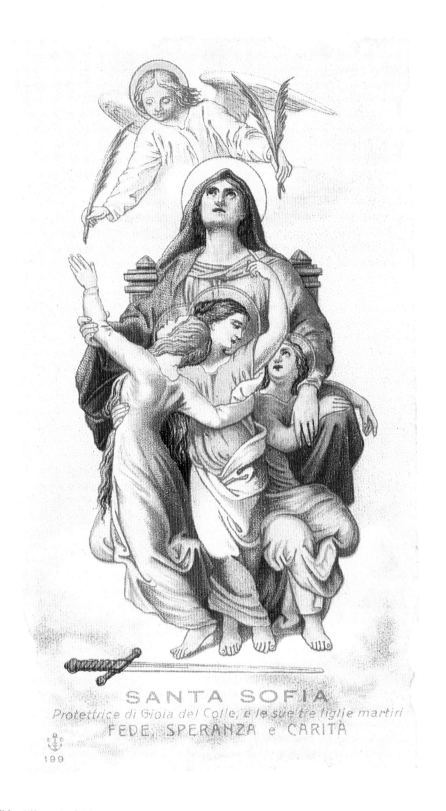

SANTA SOFIA
Protettrice di Gioia del Colle, e le sue tre figlie martiri
FEDE, SPERANZA e CARITÀ
199

SAINT SOFIA Allegorical Figure. Feast Day: August 1. Sofia means wisdom. A widow with that name had three daughters, Faith, Hope, and Charity. Her daughters were martyred under the Emperor Hadrian's persecution of Christians. Sofia died three days later while praying at their graves. An angel holding martyr's palms leads Sofia and her daughters on their ascent into heaven. The sword that beheaded the girls is at their feet.

128

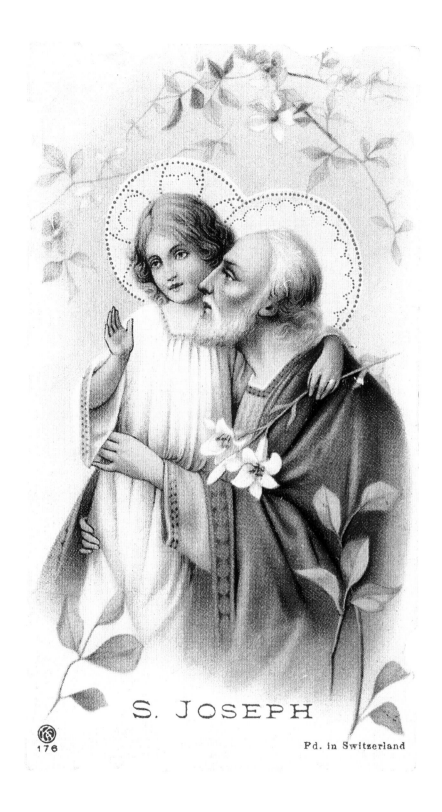

S. JOSEPH

176

Pd. in Switzerland

SAINT JOSEPH First century. Feast Day: March 19. Patron of: Fathers. Workers. Belgium. Canada. Peru. A happy death. The earthly father of Jesus Christ, Joseph never shirked his responsibilities to his family, no matter how difficult. He is depicted as an older man, holding Christ as a boy. Lilies are for his purity. Joseph has the halo of a saint and Christ has the halo reserved for divinity.

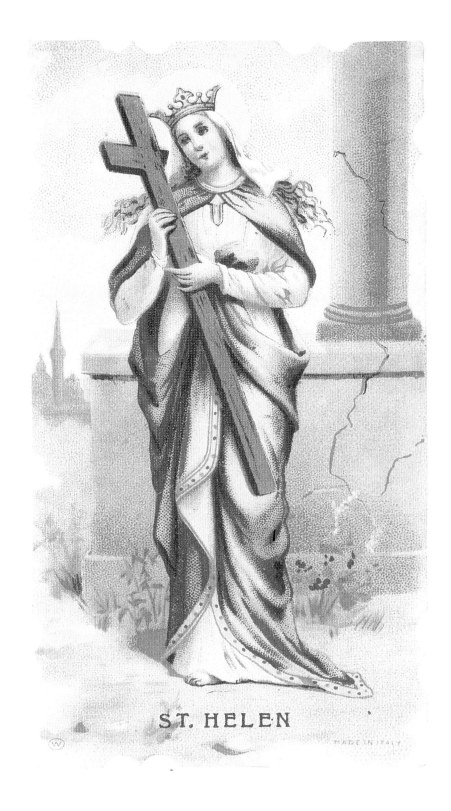

ST. HELEN

SAINT HELENA 250–330. Feast Day: August 18. Patron of: Archaeologists. Converts. Divorced people. A late convert to Christianity and the mother of Constantine the Great, Helena is always depicted holding a cross. She wears a crown because she was an empress. At the age of eighty she went on an expedition to Jerusalem to search for the true cross. She found it and built the Church of the Holy Sepulcher on the same site.

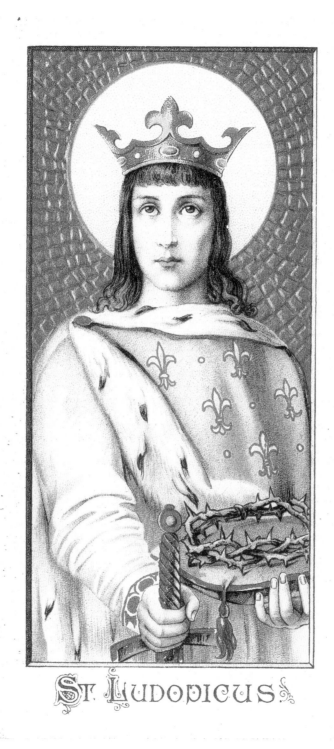

St Ludopicus

SAINT LOUIS 1214–1270. Feast Day: August 25. Patron of: Bridegrooms. Button makers. Distillers. Masons. Louis IX was King of France and an ardent supporter of the Church. He is depicted wearing the ermine of royalty and a crown with three fleurs-de-lis, the symbol of the Virgin Mary. He holds the sword of a righteous ruler and the crown of thorns, a relic he received as a gift. He built the famous Saint Chapelle in Paris to hold it.

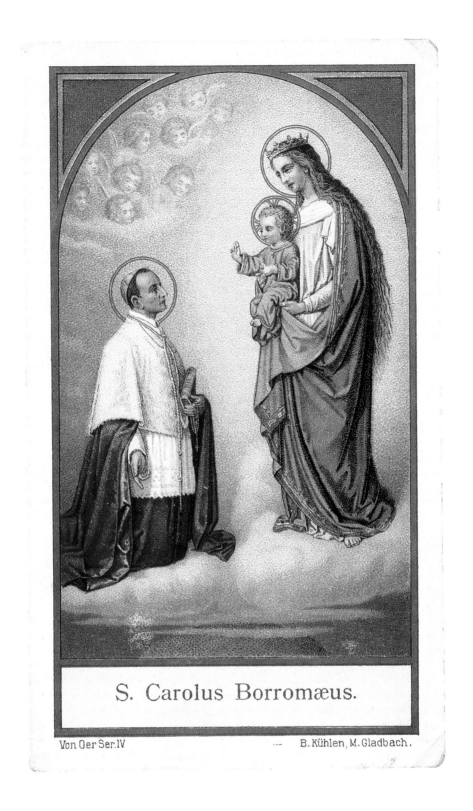

S. Carolus Borromæus.

Von Oer Ser. IV — B. Kühlen, M. Gladbach.

SAINT CHARLES BORROMEO 1538–1584. Feast Day: November 4. Patron of: Seminarians. Stomach disorder sufferers. Royally born, Charles was the nephew of a pope and the son of a Medici. Politically appointed to be the Archbishop of Milan by the age of twenty-four, he astounded those around him with his true spirituality. While his city was in the throes of a plague, he refused to leave, tending the sick and dying. He spent the rest of his fortune helping the destitute. He is shown knowing the true vision of Christ.

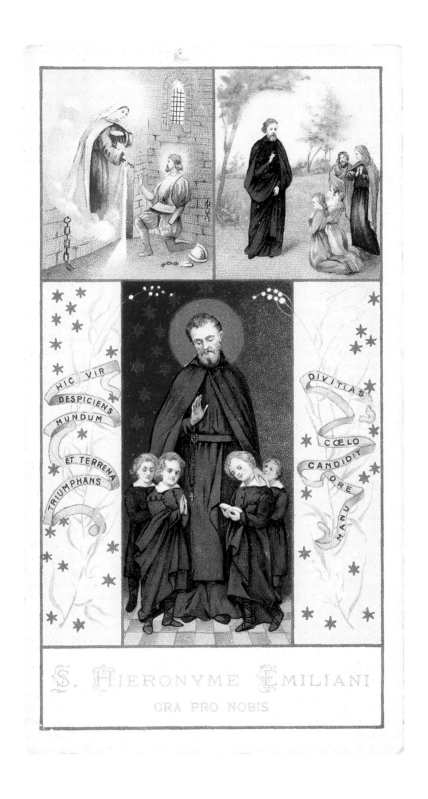

S. HIERONYME EMILIANI

ORA PRO NOBIS

SAINT JEROME EMILIANI 1481–1537. Feast Day: February 8. Patron of: Orphans. Abandoned People. After a dissolute youth, Jerome became an army officer in Treviso. He was captured and imprisoned by Venetian forces. Chained in a dungeon, he was miraculously freed by an apparition of the Virgin Mary. In gratitude he devoted his life to caring for the orphaned children of the many plague victims in northern Italy. The details of his life are illustrated and he is depicted as a protector of orphans.

133

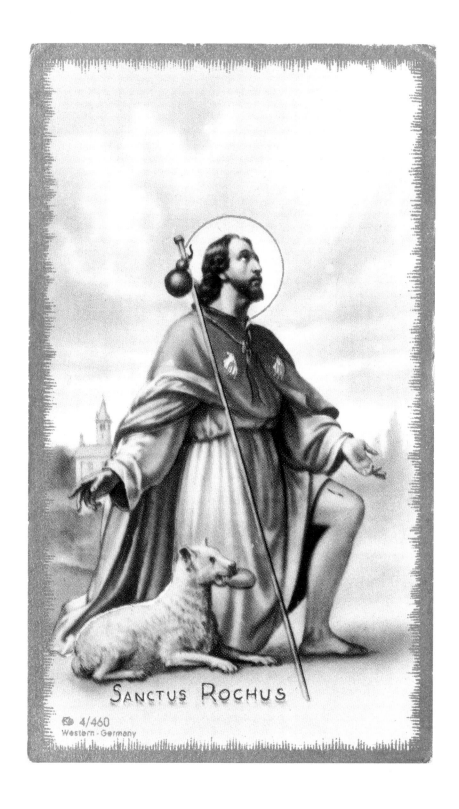

SANCTUS ROCHUS

R◎ 4/460
Western-Germany

SAINT ROCH 1295–1327. Feast Day: August 16. Patron of: Plague sufferers. Prisoners. Bachelors. A French nobleman who gave up his wealth to go on a pilgrimage to Rome, Roch came across a region of plague sufferers. He stayed to tend the sick, becoming ill himself. He wandered into the woods to die alone and was instead cared for and fed by a dog. He is shown with his pilgrim's staff, a plague sore on his leg, and the dog carrying bread by his side.

134

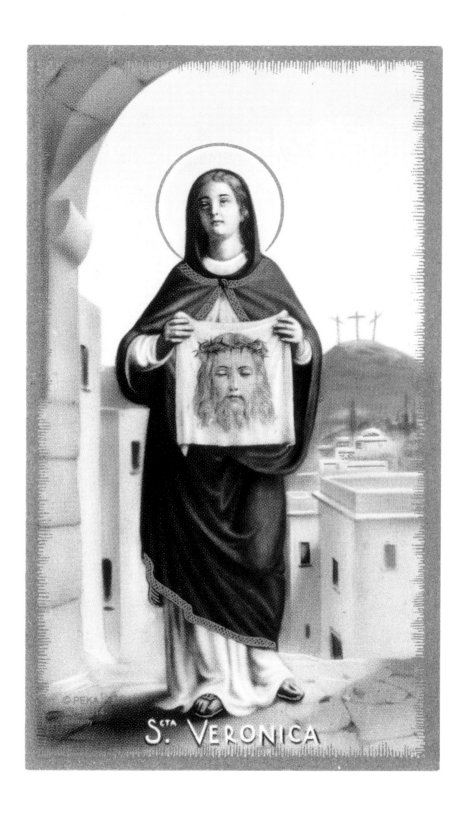

S.^{CTA} VERONICA

SAINT VERONICA First century. Feast Day: July 12. Patron of: Laundresses. Photographers. As Christ was being led to his crucifixion, a woman named Seraphia wiped his face with her handkerchief and his image remained on the cloth. *Vera icon* means "true image," giving the saint her new name. She is shown holding the image she obtained, with the crucifixion in the background.

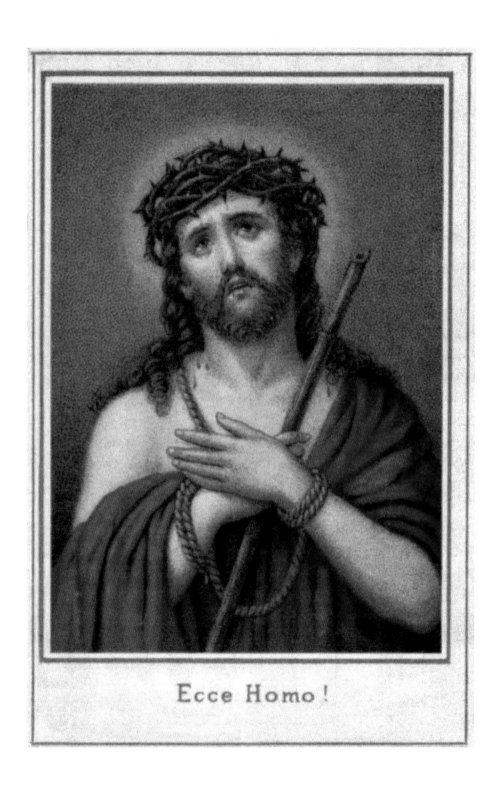

Ecce Homo!

ECCE HOMO First century. Before his crucifixion, Christ was whipped, crowned with thorns, and mockingly paraded in front of a jeering mob with the words, "Ecce, homo!" ("Behold the man!") This card depicts Christ in the darkest hour of His earthly incarnation as a man. He is draped in red, a symbol of ardent love, crowned with thorns, bound, and holding a palm branch in mockery of his status as "King of the Jews."

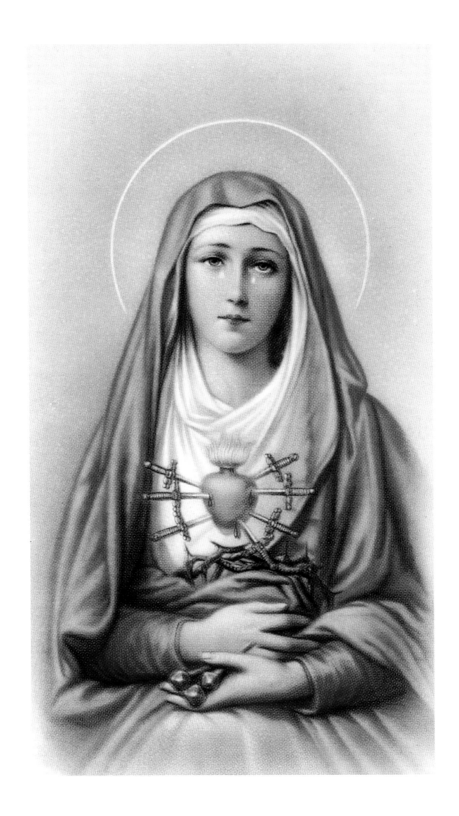

THE MOTHER OF SORROWS Mary sits holding the crown of thorns with seven knives in her heart. Each one representing one of the Seven Sorrows of Mary: 1) The prophecy of Simeon. 2) The flight into Egypt. 3) The three-day loss of Jesus. 4) The meeting of Jesus with his cross. 5) The death of Jesus on Calvary. 6) Jesus being taken down from the cross. 7) The burial of Christ in the tomb.

O SACRA ED AUGUSTA FAMIGLIA
GESÙ, MARIA, GIUSEPPE
ILLUMINATECI, SOCCORRETECI, SALVATECI

HALOS

The nimbus or halo was not used in Christian art until the third century, when it had fallen out of favor in pagan art. For several hundred years Christ was the only religious figure visually represented with a halo. Gradually, the halo became a symbol of God's grace infused in others; and saints, angels, and the Madonna were all being depicted with this celestial light around their heads. In order to distinguish different degrees of divinity, artists developed a diversity of halos.

Triangular: God the Father. A symbol of the Holy Trinity.
Square: A living person considered exemplary in his or her faith.
Radiating: A symbol of the Blessed. Not officially a saint.
Cruciform halo: A cross in the center of the halo represents Christ.

Aureole: A glow around the body. Christ is sometimes depicted surrounded by this light. The Virgin Mary has this light in pictures of her Assumption or as the Immaculate Conception.

Mandorla: Almond-shaped, solid, rays around the entire body. Originally, it represented the cloud in which Christ ascended, but in time it came to signify the light that emanates from a divine being. Mary is enveloped in this as Our Lady of Guadalupe. When it is depicted in a saint's picture it represents the complete bond that they share with Christ.

SIGNIFICANCE OF:

PLANTS, TREES, FLOWERS & FRUIT

ACACIA: Immortality of the Soul.

ACORN: Latent greatness or strength.

ALMOND: Divine Approval. The Virgin Mary.

ALOE: Comfort, soothing, a symbol of The Passion. An attribute of the Virgin Mary.

ANEMONE: Sorrow and death. In scenes of the Crucifixion.

APPLE: When held by Adam, sin, the Fall of Man. When held by Christ or depicted with Mary, salvation.

ASPEN TREE: The wood chosen for the cross. When the tree found out how it was to be used, it began to tremble with horror and has never stopped.

BALSAM TREE: The Virgin.

BAY LEAVES: Death, mourning, reward.

BIRCH TREE: Authority.

BRAMBLE BUSH: The Lord appeared to Moses as a bramble bush. Became a symbol of the Virgin Mary.

BULRUSH: Faithfulness, humility, obedience. Associated with the infant Moses. Points to the place of salvation.

BURNING BUSH: Call of Moses.

CARNATION: Red: love. Pink: marriage.

CEDAR TREE: Christ, beauty, majesty, steadfastness, prosperity, long life.

CHERRY: Sweetness of character, derived from good works.

CHESTNUT: Chastity.
CLOVER/SHAMROCK: Symbol for the Trinity. Saint Patrick.

DAISY: Innocence, the young Christ, sun of righteousness.

EASTER LILY: Resurrection of Our Lord.

EVERGREEN TREE: Immortality of the soul.

FIG: Fruitfulness, fidelity. An attribute of St. Bartholomew.

FLOWERS: Beauty, loveliness.

GARDEN: Man's innocence in his first state. Enclosed Garden or a garden with fountain: The Virgin Mary.

GLADIOLUS: The Incarnation.

GRAPES: The Eucharist. On a pole: the promised land. Twelve bunches: the Apostles. Clusters on a vine: unity of the Church.

HYACINTH: Power and peace.

HYSSOP: Purification, absolution, humility, a symbol of The Passion.

IRIS: Mary's sorrow at Christ's passion. Rival of the lily as a symbol of the Virgin Mary.

IVY: Faithfulness, eternal life.

JASMINE: Divine hope. The Virgin Mary.

LAUREL: Eternity, triumph over temptation and trial. Reward.

LEMON: Fidelity in love.

LILY: Purity, innocence, virginity. Heavenly bliss.

MANDRAKE: The Virgin Mary.

MARIGOLD: The Virgin Mary.

MYRTLE: Martyrdom, sorrow, purity, love. Gentiles converted to Christ.

OAK: Endurance, virtue, forgiveness.

OLIVE: Peace. God's anointing, charity, prosperity, faith, healing. Olive oil: works of mercy. An attribute of the Archangel Gabriel.

ORANGE: Purity, chastity, and generosity.

PALM: Martyrdom. Victory over sin and death. Everlasting life. Reward of the righteous.

PANSY: Remembrance, meditation, humility, the Trinity.

PEACH: Virtue and good works.

PEAR: Christ's love for mankind.

PLANE TREE: Christian love and character. Spreads branches high and wide.

PLUM: Faithfulness and independence.

POMEGRANATE: Because there are many seeds in a single fruit, it is the symbol of The Church. Also, immortality, fertility, hope, and royalty.

POPPY: Indifference, the sleep of death.

REED: Humiliation, Christ's Passion.

ROSE: Messianic hope. Love. Our Lord. White: purity. Red: martyrdom. Wreath: heavenly joy.

STRAWBERRY: Righteousness, good works.

THISTLE: The Fall of Man.

TREE: Faith.

VINE: God's heavenly care. Christ.

VIOLET: Humility. The Incarnation of Christ.

Significance of:

Plants, Trees, Flowers & Fruit
Continued from previous page

WATER LILY: Charity.

WHEAT: Harvest reaped from sowing the Gospel. Together with grapes, Body of Christ in the Eucharist.

WILLOW: Mourning, death, grief. The Gospel.

Objects

ANCHOR: Fixed hope. Anchor with cross: Jesus Christ, our true anchor.

ARCH: Triumph. Broken Arch: Untimely death.

ARMOR: Resistance of evil. Protection.

ARROW: Carrier of the plague. Disease. Persecution. Attack.

ASHES: Penitence. Mourning.

BAG OF MONEY: Betrayal. Open Bag of Money: Charity to the poor.

BANNER: Triumph. Victory over sin and death. Banner with white cross: Our Savior.

BASKET: Hope. Charity to the poor.

BEEHIVE: Honeyed words. Eloquence.

BELL: Music personified. Call to worship.

BELLOWS: Temptation. Bellows with lighted candle: Attempts of the devil to extinguish spiritual life.

BOOK: Learning. Authorship. Open Book: Shared teachings. The dissemination of truth. Closed Book: Divine, mysterious knowledge. The knowledge of the saints.

BREAD: Christ's body, hence His sacrifice. Loaf of Bread: Charity to the poor.

BRIDLE: Self-restraint. Temperance.

BROKEN COLUMN: Death.

CANDLE: Devotion to the Light of the World.

CENSER: Prayer, worship. Attribute of a Deacon.

CHAIN: Imprisonment. Broken Chains: Liberation. Sin overcome.

CHURCH HELD IN HAND: Distinction in building up the Christian Church.

COINS AT THE FEET OF A SAINT: Charity to the poor. Renunciation of worldly gain.

CORAL: Protection.

CORN: The Eucharist.

CROSIER: Processional staff ends in a cross. Crosier with triple tranverse: Pope's staff. Crook-shaped Crosier: The staff of an Abbot or Abbess. Symbolizes authority, jurisdiction. The end is pointed to prick and goad the slothful. The staff is straight to signify righteous rule. The crooked head is to draw souls to the ways of God. The Bishop must carry the crook outwards.

CRESCENT MOON: The Virgin Mary.

CRUTCH: Great age.

EGG: Resurrection.

FEATHERS: Three feathers through a ring, colored white, green, and red: faith, hope, and charity.

FLAME: Religious ardor.

FLEUR-DE-LIS: Derived from the lily, a symbol of the Virgin Mary. The Franks lifted a newly proclaimed king on a shield and placed an iris in his hand as a sceptre. The iris is also a flower affiliated with Mary. The fleur-de-lis is a symbol of France, adapted by the French Kings in honor of Mary.

FLOWERING ROD: Saint Joseph.

FOUNTAIN: The Virgin Mary.

GLOBE WITH CROSS: Sovereignty over the world. Globe with Serpent: Sin encircling the world.

GOLD: Wealth, kingliness, splendor.

CASKET OF GOLD: The Epiphany.

GOURD: Used by travelers to carry water. A symbol of the pilgrim.

HAMMER: With nails, Instrument of the Passion. An attribute of Helena, since she found the true cross.

HANDCUFFS: Imprisonment. Power of Hell. Broken Handcuffs: Resurrection. Death and Hell over come.

HARP: Joy. Worship in Heaven.

HORN: Strength. Intelligence. Power.

INSTRUMENTS OF THE PASSION: Crown of thorns, nails, lance, hammer, sponge and the reed to which it was attached, basin and ewer, cock, dice, IHC, ladder, lantern, scourges, silver, skull.

JEWELS: The transience of earthly possessions. Amethyst: Penitence. Diamond: Joy. Purity. Emerald: Hope. Life. Growth. Ruby: Love. Fervor. Blood. Martyrdom. Sapphire: Heaven. Truth. Wisdom.

KEY: Spiritual powers. Confession and Absolution.

Christ delivered the keys to Heaven to St. Peter.

KNIFE: Sacrifice. Martyrdom.

KNOT: Symbol of Union.

LAMP: Word of God. Good works. Truth. Divine inspiration. Enlightenment.

LIGHTNING: Vengeance of God.

MILLSTONE: Instrument of martyrdom by drowning.

MONSTRANCE: Vessel devised for making the Host visible to the faithful. A symbol of the Eucharist.

OIL: Calmness. Peace. Healing.

PADLOCK: Prudence. Secrecy.

PEN: Writer.

PURSE: Transience of earthly riches.

RING: Union.

ROCK: Symbol of Christ or Christian steadfastness. Firmness. Stability.

ROPE: Around the neck, the symbol of the Penitent.

SCALES: The Last Judgement. Used by St. Michael to weigh the souls of the dead.

SHELL: Distinctive badge of the Pilgrim to Santiago de Campostela. Since the shrine is near the coast, a shell became a convenient souvenir as well as an eating and drinking utensil.

SHIELD: Protection. Faith.

SHIP: The Church.

STAFF: Spiritual Support. Staff with Scrip or Wallet: Sign of the Pilgrim.

STAR: Energy of Christ. Symbol of the Epiphany. The

Madonna bearing Christ without losing her virginity is the same as stars sending out light without losing their brightness. Mary is frequently depicted covered in stars.

STICKS ON FIRE: Martyrdom by fire.

SUN: Truth personified. Rising Sun: Advent of Our Lord. Setting Sun: Death.

SWORD: Spiritual armament. Authority. Administration of justice. Instrument of Martyrdom.

TOWER: Chastity. Defense. Strength.

VASE: Healing. Soothing.

VOLCANO: Divine retribution.

WATER: Purification. The humaity of Christ.

WELL: Spiritual refreshment.

WHIP: Conscience. Remorse. Symbol of the Penitent.

WINE: Gladness. Rejoicing.

Colors

BLACK: Death, mourning, wickedness. Black is the liturgical color for Good Friday. Black combined with red signifies Satan. Jesus and Saint Anthony, the Hermit are both depicted in black in pictures of their temptation.

BLUE: Since blue is the color of the sky, it signifies Heaven. It also signifies divine love, truth, constancy, and fidelity. Blue and red are the vestment colors of the Madonna. Azure was the most expensive pigment, hence, the only one worthy of the Mother of God.

GREEN: Spring, hope, victory, plant life. The triumph of life over death.

GRAY: Penance, humility, wrongful accusation, or mourning. The color of ash. As a blend of black and white, it is sometimes used to express the mortality of the body and the immortality of the soul.

PINK: Grace, perfect happiness, gentleness, admiration.

PURPLE (VIOLET): Suffering, penitence, mourning, royalty. Liturgical color for Advent and Lent. Mary Magdalene wears it. The Madonna wears it as the Mater Dolorosa. Jesus Christ is depicted in it before his crucifixion and before his descent into Hell.

RED: The color of the Martyrs. It signifies blood, fire, loyalty, divine love, creative power, and the Holy Spirit. Adverse meanings: War, hatred, Purgatory, evil spirits. Red and White together signify unity. Red is the liturgical color for the Commemoration of Martyred saints and for the Pentecost.

YELLOW: Golden yellow represents the sun's glory, the bounty of God, marriage, fertility, divinity, and light.

PALE YELLOW: Since it is not pure white it is a sign of corruption, degradation, and treachery. St. Joseph and St. Peter are frequently depicted wearing gold yellow. Judas Iscariot is always shown wearing pale yellow.

WHITE: Purity, innocence, chastity, faith, light, felicity and integrity. The color of the saints who did not suffer martyrdom. White is the liturgical color of Christmas and Easter. It is worn by Jesus after the resurrection and by Mary in the Immaculate Conception and the Assumption.

Significance of:

Birds

A FLOCK OF BIRDS: Human souls.

BLACKBIRD: Temptation. The Devil.

COCK: Watchfulness. Vigilance. A symbol of Christ's Passion.

CRANE: Vigilance. Order. Loyalty. Good works.

DOVE: Peace personified. Purity. Divine Inspiration. Symbol of the Holy Spirit. Dove coming out of a person's mouth: The soul rising to heaven.

EAGLE: New life. Resurrection. Generosity. Christ's Ascension. A symbol of John the Evangelist.

FALCON: Because they are ruthless hunters easily trained, Conversion. Holy living.

GOLDFINCH: Because they eat thistles and thorns, a symbol of Christ's Passion. The soul which flies away in death.

GOOSE: Providence and vigilance.

HAWK: Watchfulness, predaciousness.

HEN: The solicitude of Christ. Protection.

HERON: The Christian who turns away from false doctrine.

LARK: Humility. The priesthood.

OWL: Solitude. Prayer. Wisdom. Owl in darkness: Satan.

PARTRIDGE: Because it seeks to gather the young of other birds, the symbol of the devil. Deceit. Theft.

PEACOCK: Immortality. Resurrection.

PELICAN: The Atonement. The Eucharist. Charity. Because it was thought to feed its own blood to its young, Christ's shedding of blood to redeem mankind.

PHOENIX: The Resurrection.

QUAIL: God's providence.

SPARROW: The lowly.

STORK: Vigilance. Piety. Chastity. The Annunciation.

SWALLOW: Because it hides itself in the mud during winter, the Incarnation. Because of its return in the Spring, Resurrection.

WOODPECKER: Heresy. The Devil.

Shapes & Numbers

CIRCLE: Since it has no beginning or end, it is a reference for God. Eternity. Perfection. Completeness.

HEXAGON: Six attributes of the Deity—Power, Wisdom, Majesty, Love, Mercy, and Justice. The base of chalices, altar crosses, and candle sticks are frequently hexagonal.

OCTAGON: Regeneration. Completion. Holy Baptism. Baptismal fonts are octagonal.

TRIANGLE: The Father, Son, and Holy Spirit.

ONE: Unity of God.

TWO: Duality. The material and spiritual. The human and divine natures of Christ. The sun and the moon. The two of every creation on Noah's ark. Male and female.

THREE: The Holy Trinity.

FOUR: The Four Evangelists— Matthew, Mark, Luke, and John. The four corners of the Earth. The four Seasons.

FIVE: The number of wounds Jesus received on the cross, therefore it is the number of sacrifice. The five senses. Jesus Christ and the Four Evangelists.

SIX: The number of creation and the created order because God created everything in six days. Six is sometimes the number of imperfection, since it falls short of seven, the number of completion.

SEVEN: The number of perfection and rest. There are seven gifts of the Spirit. Jesus spoke seven words from the cross. There are seven seals on the book of life, and seven churches in the Revelation.

EIGHT: The time of circumcision. Regeneration. Resurrection.

NINE: The number of mystery. The angels' number, there are nine choirs of angels.

TEN: Completion. The Ten Commandments. The Ten Plagues.

TWELVE: The whole church. There are twelve tribes of Israel and twelve Apostles.

THIRTEEN: Betrayal. There were thirteen Apostles at the table for the Last Supper and it was the thirteenth who betrayed Christ. This is one reason why thirteen is still considered an unlucky number.

FIFTEEN: Ascent. Progress. Fifteen steps of the temple, fifteen gradual psalms, fifteen mysteries of the rosary.

FORTY: Trial or testing. The Flood lasted forty days and forty nights. Israel wandered for forty years in the wilderness. Moses remained on Mount Sinai for forty days. After His baptism, Jesus was tempted for forty days in the wilderness. Lent lasts for forty days.

ONE HUNDRED: As ten times ten, one hundered is the number for completeness and plenitude.

ONE THOUSAND: Often used to represent incalculably large numbers or eternity.

Animals, Fish & Insects

ANT: Christian industry.

ASS: Humility. Patience. Animal of the poor.

BAT: Night. Desolation.

BEE: Tireless activity. Regal power. Chastity.

BUTTERFLY: Resurrected human soul.

CROCODILE: Hypocrisy.

DOG: Fidelity. Loyalty. Watchfulness. Orthodoxy.

DOLPHIN: Faith. Love. Society. Since they swim alongside ships, they symbolize Christ guiding the Church.

DRAGON: Satan. Dragon chained or underfoot: The conquest of evil.

FISH: Baptism. Believers. The symbol of Christ Himself.

FOX: Cunning. Fraud. Lust. Cruelty.

FROG: Because of its reappearance after winter's hibernation, the resurrection.

GOAT: Fraud. Lust. Cruelty. The damned at the Last Judgement.

HARE/RABBIT: Lust. Hare/Rabbit at the feet: Victory over lust.

HYENA: The unstable. Those who feed on false doctrine.

LAMB: Innocence. Gentleness. Patience. Humility. Symbol of Christ in His sacrificial role.

LION: Strength. Our Lord. Courage. Fortitude. Kingliness.

OX: Patience. Strength. Service. Endurance. Sacrifice.

RAM: Symbol of Christ. Leader of the herd.

SNAKE: Satan. Evil.

STAG: Piety. Devotion. Faithful Christian longing for God. Christ the Savior.

UNICORN: Purity. Feminine Chastity.

WOLF: Heresy. Gluttony. False prophets. The Devil.

Clothing

CHASUBLE: Vestment symbolizing Christian Charity.

CINCTURE: Chastity. Self restraint.

COPE: Dignity. One of the main identifying vestments of the Bishop.

CLOAK: Shelter. Righteousness. Charity.

FUR-LINED CLOAK: Royalty.

CROWN: Royalty.

DOMINICAN HABIT: A white frock covered with a black cloak. The white represents the purity of life that is covered with the black of mortification and penance. This habit was dictated by the Blessed Virgin Herself, in a vision to a monk.

HAT: Symbol of a pilgrim. Red Cardinal's Hat: Tribute to St. Jerome.

ROPE BELT: Franciscan monks wear one with three knots, symbolizing the vows of Chastity, Poverty, and Obedience.

TIARA: Headdress of a Pope. The three tiers are symbols of the Trinity or the three estates of the Church: Rome, Christendom, Spiritual Sovereignty.

VEIL: Chastity personified. Renunciation of the world. Mystery.

Body Parts

BLOOD: Life. Sacrifice. Martyrdom.

EAR: The conception of Our Lord.

EYE: The omnipresence of God.

BARE FEET: Poverty. Humility.

HAIR: Symbol of the penitent.

HAND COMING FROM CLOUD: First person of the Trinity. For the first eleven centuries of Christianity, this was the depiction of God the Father. Hand giving money: Judas.

WASHING HANDS: Innocence.

HAND HOLDING FIGURES: Souls in the hands of God.

OPEN HAND: Beneficence.

EXTENDED HAND: Protection.

HAND WITH UPWARD PALM: Invitation.

FOLDED HANDS: Prayer.

CLASPED HANDS: Holy Matrimony.

HEART: Charity.

HEART IN FLAMES: Extreme ardor.

HEART PIERCED BY THREE NAILS AND ENCIRCLED BY A CROWN OF THORNS: The 'Sacred Heart.' Shows Christ's extreme love for Mankind by His willingness to suffer.

SKULL: The transience of life. Contemplation of death. Symbol of Hermits and Penitents.

BIBLIOGRAPHY
"Saints and Their Attributes" by Helen Roeder
Publisher: Longmans Green *1955*

"How to Distinguish the Saints in Art" by Major Arthur De Bles

"Church Symbolism" by Fr. Webber
Publisher: Jansen *1938*

"Symbolism in Liturgical Art" by Leroy Appleton, Stephen Bridges
Publisher: Scribners *1959*

"Christianity and Symbolism" by FW Dillstone
Publisher: Westminister Press *1955*

WEBSITES:
Saints Unlimited: www.donet.com
Piero Stradella: Pierostradella@groups.msn.com
www.HolycardCollectors.com

PICTURE CREDITS:
All pictures are from the private collection of Father Eugene Carrella with the exception of pages:
9, 45 (St. Cecilia), 103, 136, 138—James Occhino; 28, 45 (St. Lucy), 46, 47, 72, 82, 83, 134,
135, 137— Peka Verlag; 116— Shrine of Mother Cabrini